Global Crisis and the Creative Industries

Workers in the creative industries are highly motivated, resilient, and innovative and these characteristics have come to the fore during the global health and resultant economic crises enveloping the world. This shortform book analyses transformation in the arts as a result of this era of polycrisis.

The author interrogates public policy, legislative developments, and financial support systems to assist the arts sector around the world. Utilising interview responses from various artists and creatives, the book takes the impact of the Covid-19 pandemic on the global creative industries as its central case study. It looks at the historical relationship between art and times of global crises, the policy initiatives implemented around the world in response to Covid-19 to rescue and support creative industries, explores the ways in which audiences, artists, and creatives responded during the first year of the pandemic, and looks towards future opportunities for the creative industries sector. The book also highlights the importance of higher education for the future creative industries workforce.

Providing a concise, yet holistic interpretation of the early impact of the pandemic, the book summarises recent developments and proposes future directions relevant to students and scholars involved in the creative economy.

Ryan Daniel is a professor of Creative Arts and Creative Industries at James Cook University, Australia.

Routledge Focus on the Global Creative Economy
Series Editor: Aleksandar Brkić
Goldsmiths, University of London, UK

This innovative shortform book series aims to provoke and inspire new ways of thinking, new interpretations, emerging research, and insights from different fields. In rethinking the relationship of creative economies and societies beyond the traditional frameworks, the series is intentionally inclusive. Featuring diverse voices from around the world, books in the series bridge scholarship and practice across arts and cultural management, the creative industries, and the global creative economy.

Curating, Interpretation and Museums
When Attitude Becomes Form
Sylvia Lahav

Contemporary Exhibition-Making and Management
Curating IMT Gallery as a Hybrid Space
Mark Rohtmaa-Jackson

Digitization and Culture in Vietnam
Emma Duester

Creative Work Beyond Precarity
Learning to Work Together
Tim Butcher

Youth Culture and the Music Industry in Contemporary Cambodia
Questioning Tradition
Darathtey Din

Global Crisis and the Creative Industries
Analysing the Impact of the Covid-19 Pandemic
Ryan Daniel

For more information about this series, please visit: www.routledge.com/ Routledge-Focus-on-the-Global-Creative-Economy/book-series/RFGCE

Global Crisis and the Creative Industries

Analysing the Impact of the Covid-19 Pandemic

Ryan Daniel

Routledge
Taylor & Francis Group

LONDON AND NEW YORK

First published 2024
by Routledge
4 Park Square, Milton Park, Abingdon, Oxon OX14 4RN

and by Routledge
605 Third Avenue, New York, NY 10158

Routledge is an imprint of the Taylor & Francis Group, an informa business

British Library Cataloguing-in-Publication Data
A catalogue record for this book is available from the British Library

Library of Congress Cataloging-in-Publication Data
Name: Daniel, Ryan (Ryan James), author.
Title: Global crisis and the creative industries: analysing the impact of the covid-19 pandemic / Ryan Daniel.
Description: 1 Edition. | New York, NY: Routledge, 2024. | Series: Routledge focus on the global creative economy | Includes bibliographical references and index.
Identifiers: LCCN 2023037847 (print) | LCCN 2023037848 (ebook) | ISBN 9781032562438 (hardback) | ISBN 9781032562452 (paperback) | ISBN 9781003434603 (ebook)
Subjects: LCSH: Cultural industries. | Employees–Training of. | Business planning. | COVID-19 Pandemic, 2020—Influence.
Classification: LCC HD9999.C9472 D36 2024 (print) | LCC HD9999.C9472 (ebook) | DDC 338.4/77–dc23/eng/20230814
LC record available at https://lccn.loc.gov/2023037847
LC ebook record available at https://lccn.loc.gov/2023037848

ISBN: 978-1-032-56243-8 (hbk)
ISBN: 978-1-032-56245-2 (pbk)
ISBN: 978-1-003-43460-3 (ebk)

DOI: 10.4324/9781003434603

Typeset in Times New Roman
by MPS Limited, Dehradun

Contents

About the Author

Ryan Daniel is a professor of Creative Arts and Creative Industries at James Cook University, Australia. He holds the degrees of *Bachelor of Music Honours* (Class I and University Medal) from JCU, *Master of Music* from the University of Cape Town, *Doctor of Philosophy* from JCU, and piano performance diplomas from Trinity College London (FTCL, LTCL) and the Australian Music Examinations Board (L.Mus.A). His research is published in journals including *Creativity Studies, Creative Industries, International Journal of Cultural Policy, Arts and Humanities in Higher Education, International Journal of Teaching and Learning in Higher Education, Studies in Higher Education, Music Education Research*, and the *British Journal of Music Education*. Professor Daniel has been the recipient of significant awards for his teaching, including twice the JCU Vice Chancellor's Citation for teaching excellence (2004, 2006), as well as a national Australian Learning and Teaching citation (2010). In both 2018 and 2019 he has been the recipient of the JCU Graduate Research School "Supervisory Panel of the Year" award with his colleagues.

Acknowledgements

This text would not have been possible without the substantial contribution and efforts of the interview participants featured in Chapter 3, whose willingness to share their stories relevant to the pandemic revealed their courage and commitment to creative industries and sense of care and concern for humanity. I would also like to acknowledge the contributions of Nigel Unsworth (photographer), Dr Eileen Larsen (graphic designer), and Lauren Moxey (editorial work).

Introduction

The creative industries are typically one of the most impacted areas during times of global crisis; since early 2020, this sector has been severely impacted by the Covid-19 pandemic. Although there are other terms used to describe the sector,[1] the creative industries comprise practices focused on the activation and application of intellectual property across traditional arts-based disciplines (e.g., visual arts, music, theatre, and dance), those with a commercial focus (e.g., design, software, gaming, and photography), and allied areas (e.g., museums, publishing, and advertising). It is one of the biggest areas of the global economy, employing millions of specialist creatives; support workers such as cultural leaders, administrators, and technicians; and those embedded in other industries, for example designers working for a multinational food distribution company. Considered to be "one of the most dynamic and fastest growing segments of the global economy" (Gnezdova et al., 2022, p. 160), creative industries are estimated to contribute over 7% to the world's current GDP, with this number growing to over 10% in the future (Khlystova et al., 2022).

The current Covid-19 pandemic is a black swan event – an ongoing existential crisis and historic disruption that few could have anticipated in terms of its devastation to societies, global economies, and, in relation to the focus of this text, the creative industries sector. Its early impact has been described as "rapid and devastating" (Banks & O'Connor, 2021, p. 1), a "seismic shock to what was already a fragmented and exhausted sector" (Reason et al., 2022, p. 542), and a time of "deep rupture and profound transition" (Davis & Boler, 2022, p. 356). The current crisis has also been referred to as having "frightening epidemiological, social, cultural, and geopolitical implications" (Erni & Striphas, 2021, p. 211), hence creative industries have been and will continue to be deeply affected (Robinson, 2023). The sector continues to rebuild during a time of *creative destruction*, a concept first theorised in 1942 by the leading 20th century economist Joseph Schumpeter that refers to the dismantling of previous practices in order to make way for the new (Schumpeter, 2010).

DOI: 10.4324/9781003434603-1

In the early months of 2020, doors to museums, performing arts centres, art galleries, and other spaces for creative production were partially or completely shut. Festivals, public arts events such as art fairs and conferences, art tours, and popular music concerts in various venues were cancelled. Film studios either completely shut down projects, significantly modified them, or accelerated their schedules in the hope of completing work before government policies and public health interventions were imposed. Every part of the creative industries sector was affected in small to, at worst, catastrophic ways. The sector was considered the first to close and likely to be the last to fully reopen (Yue, 2022). In the early days the pandemic was described by the Nobel Prize winning artist Bob Dylan as "a forerunner of something else to come. Maybe we are on the eve of destruction" (Dylan in Brinkley, 2020). This creative destruction became evident over the ensuing period, and it has recently been described as "far from being over" (de Valck & Damiens, 2023, p. 12).

Although several nations set out to implement support or rescue packages for creative industries as quickly as possible, and to some degree of success particularly in Europe and the United Kingdom (Salvador et al., 2021), millions of freelance and sessional arts workers were either not eligible for such programs (Shaughnessy et al., 2022), or discovered funding to their contracting organisation was insufficient to support the employment of all workers, and for any extended period. The onset of the pandemic amplified the already precarious nature of work in creative industries. Salvador et al. (2021) provide a detailed examination of various initial policy responses and initiatives implemented in Europe and the UK, highlighting the types of response, their application and country or countries of focus, and the relative success of these strategies. They demonstrate that there were both complexities involved in determining who and what policy responses were for – given the ongoing lack of clarity surrounding what the creative industries sector is in practice – and challenges associated with gathering data in relation to how certain parts of the sector responded in light of these various policy implementations.

Salvador et al. (2021) also highlight how artists and arts workers have, in general, suffered from an economic, structural, cultural, and social standpoint – perhaps more so than any other industry. Those who remain in the sector continue to endure numerous professional and personal hardships, including loss of work opportunities, reduced income, rapidly shifting models of production and consumption, negative perceptions within public circles about the value of the creative industries, increased mental health pressures, and challenges to their wellbeing. The perceived pre-existing fragility of the sector (Reason et al., 2022) has been dramatically increased by the onset of shutdowns, lockdowns, and ongoing disruption.

The human cost of the pandemic cannot be underestimated. At the time of writing, the Johns Hopkins Coronavirus Resource Center had collected data across the period 22 January 2020 to 10 March 2023, in terms of both the number of confirmed cases and the deaths caused by the pandemic. The figures are staggering; they recorded nearly 680 million cases of the virus worldwide and almost seven million deaths across this time frame. These figures rely on reported cases and there is significant likelihood that many more cases and deaths – potentially in the millions – have gone unreported, most likely in developing countries or those that have been selective in what they are prepared to report in public fora. Across this three-year period there have been waves and surges in cases and deaths; the virus itself has mutated into other strains, and despite the administering of over 13 billion vaccine doses (Johns Hopkins Coronavirus Resource Center, 2023), the virus continues to spread alongside ongoing speculation regarding the current and anticipated effects of what is widely referred to as "long Covid".

Despite the very serious challenges that the pandemic has caused for artists and support workers in creative industries, lockdowns in fact led to major increases in engagement with creative content by the broader public. This represents a contradiction, in that on the one hand creators lost multiple work opportunities, yet on the other hand users increased their engagement with *everyday creativity* (e.g., cooking, sewing, knitting, singing, and gaming) (Lee, 2022). Users also gained new experiences and engagements with arts and culture, as both individual artists and cultural institutions moved content into online spaces as quickly as possible. People visited virtual galleries, viewed performances online, experimented with new creative activities, developed or finished creative projects of various kinds and complexities, and sought refuge and comfort through creativity and creative artefacts. There were significant rises in the uptake of online content through providers such as YouTube, Spotify, Netflix, Disney+, and Amazon, and social media platforms such as Instagram and TikTok. Recently developed platforms for creative content and interaction also saw major increases in users and activity, such as the dance application Avonya and social audio application Clubhouse.

Online book subscriptions and distribution grew significantly, and sales of artworks increased in some parts of the world as citizens used lockdowns as a time to redecorate their homes. The drive-in cinema had somewhat of a comeback, in order that people could socially distance yet still enjoy a film experience. Cultural institutions invested heavily in the shift to online content in the hope of retaining and growing audiences; the pace of innovation therefore quickened, and access to arts and culture was further democratised. The convergence of on-site experiences – the previous dominant model – with those of a digital nature has been

accelerated by the pandemic, as have ongoing efforts to experiment with new modes for enabling audience engagement and interaction with creative content.

Although the key participants in the creative industries sector suffered enormous losses and stressors, lockdowns did enable many to undertake a period of refresh, renewal, or simply to rest. Those who decided to remain in the sector and not flee to other industries where work may have been more readily available focused on such activities as the development of new creative content, the formation of further in-country or global collaborations, the expansion of a digital presence or audience reach, and professional development through online courses and workshops. Artists responded rapidly and the arts sector and its millions of workers have, in general, found ways to deal with the current pandemic; this resilience and adaptability are qualities inherent to working in this sector (Giusti, 2023). Although resilience is often the focus point of discussions and debates during times of crisis, Adelman (2021) argues that rather than emphasise this typically neoliberal and deficit-oriented discourse, creative industries participants, commentators, and researchers should lean towards the more positive framework of *endurance*, a concept which is accessible during the moment that is Covid-19, and for however long it continues to linger.

Artists have always been and will continue to be highly motivated, persistent, and innovative, given it is well-documented that the creative industries sector requires these attributes and regardless of any existential crisis. To some extent, the creative industries sector is always facing some form of predicament (Skaggs, 2023), including government policy changes, funding cuts and unforeseen changes to funding allocations, declining and changing audiences in some fields of creative practice, rapid growth in online platforms at a speed that some creative industries workers struggle to match, user engagement patterns that outpace appropriate business models to support artists, royalty and copyright issues, and geopolitical factors such as the effects of Brexit or tensions between the West and the East which have reached another peak since Russia's invasion of the Ukraine in early 2022. Given creative industries regularly face crises both within the sector and from external events, they are regarded as being both particularly vulnerable and prone to economic shock; despite this, they continue to attract and retain resilient institutions and workers (Khlystova et al., 2022).

The pandemic has reignited debates in relation to the value of creative industries. It has once again drawn attention to this sector, raised numerous philosophical, social, and fiscal questions relevant to its place and future, and required those within the sector to again question how it will survive, rebound, and eventually return to some stability and, more importantly, a new level of thriving. It has reinforced the need for the

sector to have robust data to report to governments, and for its key leaders and leadership groups to work together in order to lobby governments for similar levels of support to that provided to other industries. The sector is frequently subject to the policy and funding settings of the government of the time, with political decision-making often sporadic or unpredictable. For example, as recently as April 2023, the esteemed music conductor Simon Rattle expressed his considerable disdain at sudden funding cuts to several of the major performing arts organisations in the UK in the areas of music, opera, and theatre, describing it as "cultural vandalism" (Rattle quoted in Westwood, 2023).

The Purpose of This Text

This text seeks to explore these various issues of critical relevance now and that will be of importance to the future of the sector, and in order to respond to calls for the urgent need for ongoing research relevant to creative industries and the impact of the pandemic (Khlystova et al., 2022). It aims to build on the work of many authors' research and writings about the pandemic's influence on the creative industries to date, explores and analyses how the recent crisis is transforming the arts, considers relevant policies and legislation, and looks for indicators of success achieved within the creative industries during this tumultuous period. It aims to challenge the statement by Khlystova et al. (2022) that "creative industries have not shown a sufficient resilience to the COVID-19 pandemic overall" (p. 1204). Further, it also aims to contribute to the research gap raised by Duarte and Gauntlett (2022), who argue that creative individuals who operate independently have been overlooked in terms of how they responded to the crisis.

Global perspectives, initiatives, and interventions are explored, including what the "new normal" might resemble for the creative industries sector across the next two to three decades. This includes the insights of 35 creative practitioners interviewed as part of the writing of this text. One of the ongoing issues for the sector is its inherent fragmentation and diverse range of creative fields, forms of practice, business models, and audience segments; this is also considered and reflected on in the four main chapters of this text. Further, there is an ongoing need for the creative industries sector to present itself as coherently as possible to key stakeholders in government, and "essential for policy-makers to design long-term employment support schemes for the creative industries" (Khlystova et al., 2022, p. 1201).

As authors such as Harper (2020) and Salvador et al. (2021) have indicated, longer-term issues for creative industries and how they might recover are far more difficult to assess. This is because as the pandemic continues, there are numerous unknowns regarding where the ongoing

shift to digital models of creation and distribution will lead, questions about the future for in-person experiences remain, and there is an urgent need to continue to interrogate shifting patterns of user consumption. Data continue to emerge which provide insights into sector recovery and which will be explored in Chapter 2 in particular; however, it is clear that recovery is both an ongoing challenge but also an opportunity for those in the sector.

Many questions remain unanswered as the sector continues to rebuild; for example, what longer-term impact will the pandemic have on the symphony orchestra, which pre-pandemic was already struggling to attract and retain audiences? Will audiences be comfortable to return to performing arts theatres, large stadiums for rock concerts, or various types of arts festivals and venues when they will be in close proximity to others? Or, are the general public now comfortable and accustomed to in-home experiences of such events and engagement through digital channels that in-person experiences will be permanently affected? Will users be prepared to pay what is necessary in order for organisations and individual artists to sustain the high costs of streaming the performing arts or providing virtual art experiences such as online gallery tours and presentations?

There is nothing like the anticipation that one experiences when attending a live performance, be it in an intimate theatre space, a large concert hall, or a major stadium. Similarly, the opportunity to view an artwork in a museum or gallery is an aesthetic experience that cannot be truly replicated in the online space. The senses are often far more stimulated and alive when attending venues in person as against viewing work online. At the same time, the shift to online and digital platforms democratises arts and culture to the extent that citizens living in remote locations can hear one of the world's great orchestras, see exquisite artworks, be challenged by new forms of creative practice, or hear from high-profile creatives in fora such as online conferences, seminars, interviews, or artist talks.

There are many high-stakes questions and important issues for policymakers, institutions, and individual artists as the world moves towards some form of post-Covid normality. The implications for the creative industries sector are significant (Canham, 2023; Howard et al., 2021), particularly in relation to the latest disruptions and opportunities created by artificial intelligence and other cutting-edge technologies, the future landscape of hybrid models of work and learning, and the many unknowns as to what the future workforce will require in terms of skills and attributes. There is also a significant need for further research, particularly in terms of developing more sophisticated quantitative and mixed methods research methodologies relevant to creative industries

(Khlystova et al., 2022). The current situation is summed up well in the following statement by Snowball and Gouws (2022), who argue that:

> The Covid-19 pandemic represents a permanent change in creative economy business models, and in the ways in which audiences consume and participate in cultural and creative activities. Even after the pandemic has passed, there will be a need to design policies and support strategies to assist the sector to adapt to the new reality if they are not to fall behind. (Snowball & Gouws, 2022, pp. 21–22)

This text hopes to give readers some insights into how the future for the creative industries might unfold in a world that is in the midst of a *polycrisis* and that has been changed forever. Covid-19 continues, with infections and deaths continuing to be reported. Although peaks and surges in the virus appear to have waned, societies continue to try to reclaim some sense of normality, albeit often with enhanced public health protocols, such as the use of masks and social distancing. What remains unclear is how long the virus might linger, the health and economic effects of long Covid, and what the future might look like for societies and economies. Whatever the future, creative industries will continue to survive, and the role they will play in the fabric of societies remains a very imaginative and exciting space.

Following this **Introduction**, Chapter 1 – **The Arts and Times of Crisis** – considers lessons and learnings from the past, identifies some of the great artworks linked to key moments in history, and looks at recent policy changes and support packages for creative industries in response to the current pandemic. Chapter 2 – **The Impact of Covid-19 on Arts Audiences** – presents recent data and trends in patterns of user engagement, and possibilities for future audience participation and involvement in creative industries. Chapter 3 – **Artists' and Creatives' Motivation and Innovation during the Pandemic** – explores the ways in which artists, organisations, and the sector have responded to the pandemic, including possibilities for future creative practice. This chapter includes the voices of 35 creative industries participants interviewed for the purposes of this text. Chapter 4 – **Educating Artists and Creatives for a Post-pandemic World** – looks towards the imperatives and possibilities for education at the tertiary level, and the preparation of the next generations of creative industries practitioners. The **Conclusion** seeks to synthesise, energise, and inspire thinking around the key issues and future possibilities for creative industries.

Note

1 *Creative industries* is a concept and term that came to the fore in the 1990s in particular. It is often used interchangeably with other terms such as cultural industries, cultural and creative industries, creative cultural industries, creative economy, arts sector, entertainment industries, or the experience economy. Most recently, it has been referred to as the creative and digital industries (Gnezdova et al., 2022). For more on this concept, including stakeholder views, see Daniel (2017).

References

Adelman, R.A. (2021). Enduring COVID-19, nevertheless. *Cultural Studies*, *35*(2–3), 462–474. 10.1080/09502386.2021.1898014

Banks, M., & O'Connor, J. (2021). Editorial: Art and culture in the viral emergency. *Cultural Trends*, *30*(1), 1–2. 10.1080/09548963.2021.1882063

Brinkley, D. (2020, June 12). Bob Dylan has a lot on his mind. *The New York Times*. https://www.nytimes.com/2020/06/12/arts/music/bob-dylan-rough-and-rowdy-ways.html

Canham, N. (2023). Living with liminality: Reconceptualising music careers education and research. *Research Studies in Music Education*, *45*(1), 3–19. 10.1177/1321103X221144583

Daniel, R. (2017). The creative industries concept: Stakeholder reflections on its relevance and potential in Australia. *Journal of Australian Studies*, *41*(2), 252–266. 10.1080/14443058.2017.1305431

Davis, E., & Boler, M. (2022). Affect, protest, pandemic: Conversations from the crises of 2020. *Cultural Studies*, *36*(3), 355–359. 10.1080/09502386.2022.2040560

de Valck, M., & Damiens, A. (Eds.). (2023). *Rethinking film festivals in the pandemic era and after*. Springer International Publishing. 10.1007/978-3-031-14171-3

Duarte, V., & Gauntlett, D. (2022). Adapting, surviving, discovering: Creative practitioners in the COVID-19 crisis. *Journal of Creativity*, *32*(2), 100027. 10.1016/j.yjoc.2022.100027

Erni, J.N., & Striphas, T. (2021). Introduction: COVID-19, the multiplier. *Cultural Studies*, *35*(2–3), 211–237. 10.1080/09502386.2021.1903957

Giusti, S. (2023). Museums after the pandemic, from resilience to innovation: The case of the Uffizi. *International Journal of Cultural Policy*, 1–14. 10.1080/10286632.2023.2167986

Gnezdova, J.V., Osipov, V.S., & Hriptulov, I.V. (2022). Creative industries: A review of the effects of the COVID-19 pandemic. In V. Osipov (Ed.), *Post-COVID economic revival: Sectors, institutions, and policy* (Vol. 2, pp. 159–171). Palgrave Macmillan. 10.1007/978-3-030-83566-8

Harper, G. (2020). Creative industries beyond COVID-19. *Creative Industries Journal*, *13*(2), 93–94. 10.1080/17510694.2020.1795592

Howard, F., Bennett, A., Green, B., Guerra, P., Sousa, S., & Sofija, E. (2021). 'It's turned me from a professional to a "bedroom DJ" once again': COVID-19 and new forms of inequality for young music-makers. *YOUNG*, *29*(4), 417–432. 10.1177/1103308821998542

Johns Hopkins Coronavirus Resource Center. (2023, March 10). *COVID-19 Dashboard*. https://coronavirus.jhu.edu/map.html

Khlystova, O., Kalyuzhnova, Y., & Belitski, M. (2022). The impact of the COVID-19 pandemic on the creative industries: A literature review and future research agenda. *Journal of Business Research, 139*, 1192–1210. 10.1016/j.jbusres.2021.09.062

Lee, H.K. (2022). Rethinking creativity: Creative industries, AI and everyday creativity. *Media, Culture & Society, 44*(3), 601–612. 10.1177/01634437221077009

Reason, M., Conner, L., Johanson, K., & Walmsley, B. (2022). Afterword: Covid-19, audiences and the future of the performing arts. In M. Reason, L. Conner, K. Johanson, & B. Walmsley (Eds.), *Routledge companion to audiences and the performing arts* (pp. 535–543). Routledge. 10.4324/9781003033226

Robinson, J. (2023, May 5). Not all recoveries are created equal: A snapshot of the 4 genres. *TRG Arts*. https://trgarts.com/blog/not-all-recoveries-are-created-equal.html

Salvador, E., Navarrete, T., & Srakar, A. (Eds.). (2021). *Cultural industries and the Covid-19 pandemic: A European focus*. Taylor and Francis. 10.4324/9781003128274

Schumpeter, J.A. (2010). *Capitalism, socialism and democracy* (1st ed.). Routledge. https://doi.org/10.4324/9780203857090

Shaughnessy, C., Perkins, R., Spiro, N., Waddell, G., Campbell, A., & Williamon, A. (2022). The future of the cultural workforce: Perspectives from early career arts professionals on the challenges and future of the cultural industries in the context of COVID-19. *Social Sciences & Humanities Open, 6*(1), 100296. 10.1016/j.ssaho.2022.100296

Skaggs, R. (2023). Socially distanced artistic careers: Professional social interactions in early, established, and late career stages during COVID-19. *Poetics*, 101769. 10.1016/j.poetic.2023.101769

Snowball, J.D., & Gouws, A. (2022). The impact of COVID-19 on the cultural and creative industries: Determinants of vulnerability and estimated recovery times. *Cultural Trends, 32*(3), 207–230. 10.1080/09548963.2022.2073198

Westwood, M. (2023, April 14). Politicians are worried about an elitist tag … this is cultural vandalism. *The Australian*. https://bit.ly/41k1wRe

Yue, A. (2022). Conjunctions of resilience and the Covid-19 crisis of the creative cultural industries. *International Journal of Cultural Studies, 25*(3–4), 349–368. 10.1177/13678779221091293

1 The Arts and Times of Crisis

Art and Crises in History

Many of the great creative works from past centuries have been directly or indirectly linked to major historical events and crises, such as plagues, revolutions, or world wars. This includes works by great **visual artists** (e.g., Raphael, van Dyck, Munch, Picasso, Hopper, and Munch), **composers** (e.g., Bach, Haydn, and Chopin), and **writers** (e.g., Boccaccio, Defoe, and Shakespeare). Artists are inspired or motivated to produce work that sets out to respond to and make sense of the turmoil – the social and emotional impact, the mortality and fragility of life – and that offers a means by which viewers, readers, or listeners develop their own understanding of life-changing and often horrific events and periods of time.

When global crises eventually pass – some, such as the great plague in Europe, taking centuries to do so – it is these great creative artefacts that remain and offer both a historical record and a means by which later generations can develop an understanding of the nature of the crisis and its effect on humanity and societies. It is also possible that for many artists, one of their conscious or subconscious intentions may have been to use their creative work to remind and influence future generations as to the tragic consequences of these global crises, in the hope that it may go some way towards shifting attitudes and understandings and, in an ideal world, preventing further catastrophes.

History demonstrates that, during a crisis, there is often a significant increase in the number of works that respond to the event, through visuals, texts, or sounds. One of the most significant pandemics in history – the great plague or "Black Death" – initially decimated populations in Europe between 1348 and 1350 and continued with recurrent outbreaks up to the 17th century. It was depicted in paintings by a number of visual artists, such as Raphael and van Dyck, and became somewhat of a genre in itself, with some works regarded as exemplary visual depictions. One of these is the painting *The Triumph of Death* by Bruegel (1562-1563) the

DOI: 10.4324/9781003434603-2

Elder, where "in the foreground and center of the picture Death himself drives a great ox-cart while wielding a scythe to reap his grim harvest" (Snowden, 2019, p. 54).

Writers have also produced notable outputs during times of crisis. Shakespeare, in such works as *King Lear* (1605–1606) and *The Winter's Tale* (1610–1611), directly references the great plague that he was witness to at the time, and Boccaccio's *Decameron* (1349–1353) is regarded as a vivid description of how people fled cities during the plague to rural and other safer environments. More recently, Albert Camus' *The Plague* (1947) is regarded as a classic of modern literature, even though when published it "reopened a painful chapter in the recent French past" (Judt, 2001, p. viii) – the occupation of France by the Nazis for four years during World War II.

Composers have also been very active in writing music in response to major historical and often tragic events. This includes some of the greatest composers in the Western art tradition such as Bach, Haydn, Beethoven, and Tchaikovsky. Key works include Haydn's *Mass in the Time of War* (1796), written at a time when Austria feared invasion by the French, Beethoven's *Eroica* symphony (1803–1804) with its links to the French revolution, and Tchaikovsky's *1812 Overture* (1812), which was written to celebrate Russia's successful resistance to French invasion. The Baroque composer Bach, in his 25th Cantata *Es ist nichts Gesundes an meinem Leibe* (There is nothing sound in my body) (1723), focused on the great plague in Europe and the death of approximately 100,000 people in France over a short period of time. In the text of this work, there is a vivid description of the realities of the pandemic: "The whole world is nothing but a hospital, where in numbers too great to count people, and even children in their cradles, lie down in pain and sickness" (Bach Cantatas, 2023).

One of the notable 20th-century music compositions linked to a global crisis is that by the Polish composer Penderecki with his *Threnody to the Victims of Hiroshima* (1960), written in response to the first use of nuclear weapons in World War II. This confronting work, with its aesthetic of screaming, shrieking, and agonising string sounds, draws the listener into what must have been the utter torment experienced by the victims of this nuclear attack and those who had to live with various forms of post-event trauma, such as the loss of loved ones, various forms of cancer, and birth deformities. Many Japanese composers also wrote music in response to this same event, such as Masao Ohki's *Symphony No. 5 "Hiroshima"* (1953), with pathos and anguish again evident in its aesthetic.

The infamous Spanish flu that took hold in 1918, emerging at the tail end of World War I, was another crisis involving a catastrophic loss of human life around the world, and is arguably the greatest pandemic the

world has seen. This crisis influenced some visual artists such as Edvard Munch to create self-portraits before and after the crisis, and Egon Schiele to create work depicting the loss of human life during this time. Following on so soon after the devastation caused by World War I, a global conflict and war depicted in such works as those by the German visual artist Otto Dix, the Spanish flu added further to the tremendous sense of loss and hopelessness in societies as tens of millions fell victim to the virus.

Amidst the destruction and absurdity of the first third of the 20th century, the art world continued to react and innovate, with the Dada art movement developing around the time of World War I, and which carried the visual arts into new territory via equally absurd works. The Bauhaus movement also emerged at this time (approximately 1919), which bridged the design and the art worlds and led to modern trends in architecture and design. Across the 20th century, photographers captured moments in time across a range of crises, be these empty city spaces, human tragedy, the brutality of war, environmental destruction as well as – at times – hope and hopefulness. Notable examples are the photographic images of Joe Rosenthal and Robert Capa that captured key moments in time during World War II. A recent image by artist-photographer Unsworth (2022) (as seen in Figure 1.1) reflects the stark and eerie emptiness in cities and places during the current pandemic – a common phenomenon during times of lockdown.

Figure 1.1 Nigel Unsworth, *Untitled*, 2022, digital photograph. Online. Copyright: Nigel Unsworth.

In the popular music field, and in response to the famine crisis in Africa in the 1980s, the top-selling popular music track *We Are the World* (1985) was written and recorded, and which raised millions of dollars for food relief. This same work was re-released by a similarly high-profile group of musicians in 2010 to raise funds for Haiti, a small Caribbean country with a history of incredible poverty and social inequalities, which was further devastated by a major earthquake in 2010 and suffered a tremendous loss of life (up to 300,000 deaths), billions of dollars of damage to infrastructure, and a loss of hope, with Haiti still attempting to rebuild and find a sense of order even today (Bland, 2023).

Not long after this destructive earthquake in Haiti, another devastating event occurred in Japan in 2011. A severe earthquake led to a series of major tsunamis, which pounded the Japanese coastline, causing significant loss of life, widespread damage to infrastructure including nuclear power stations, and the loss of major tracts of farming land. The recovery and rebuilding process remains underway in 2023. This particular disaster and crisis has been documented by numerous artists, such as the photographer Takashi Arai, whose compelling images leave an indelible impression on the viewer. These include his *Exposed in a Hundred Suns* series which is a reflection of the recent tsunami and nuclear disaster, as well as images referencing the atomic bombings by the US during World War II (Arai, 2023).

The importance of art during times of crisis is also evidenced by the way that societies of the time made urgent moves to preserve and protect creative and cultural artefacts, particularly during significant military conflicts. During World War II, the Monuments Men (a group of mostly male and some female art curators and professors) risked their lives in order to save tens of thousands of artworks from the Nazi looting strategy – works which would have been destroyed or lost forever without their interventions. They rescued and retrieved works by cultural icons such as Michelangelo, Vermeer, van Eyck, Rembrandt, and countless Jewish artists. In 2003, efforts were made to preserve what was not already looted from the National Museum in Iraq during the conflict with the West; the United Nations even approved a resolution for the urgent protection and retrieval of art and cultural works in Iraq given the centuries of history that were captured in the country's monuments and creative artefacts (UNESCO, 2015).

Most recently, the war in Ukraine has led to cultural historians and curators making urgent moves to rescue and safely store countless works of art in both analogue and digital forms, as well as protecting cultural sites and public artworks (Young, 2022). The fallout, loss of work, and damage to cultural sites and public art is yet to be determined in Ukraine, given that in mid-2023 the war shows no signs of abating. Hence, the protection and preservation of artistic and cultural artefacts

is still occurring. There will no doubt be great losses, but passionate citizens and protectors of arts and culture have seen the importance of preserving works that represent Ukraine's history and national identity for the benefit of current and future generations.

Stories are also emerging that show how art has been a powerful tool for Ukrainians during the war, with the recent contemporary music track *Metro* by poet, novelist, and singer Serhiy Zhadan both encapsulating the horror of the lived experience of sheltering in underground train stations during Russia's ongoing shelling of the city of Kharkiv, and also declaring that love and strength will guide people through (Higgins, 2023). Further evidence is shown in the tireless efforts of the Ukrainian artist Mykola Kolomiets, who turned his underground artist studio into a bomb shelter during raids on the city of Kharkiv, and who also ran art classes for children in order to provide escape and joy, and to provide a sense of routine and an outlet to express their emotions in response to the trauma of ongoing shelling and missile attacks (Higgins, 2023).

Crises and Disruptions to Creative Industries

Global crises have typically had a significant effect on artists, their work, and the creative industries. The Black Death plague caused major disruptions to the art world, with many artists succumbing to the plague and arts productivity in general slowing substantially. Meiss (1973) contends that much of the work that followed the initial disastrous period (approximately 1346–1349) had a dark aesthetic, characterised by a pervasive sense of fear and dread and an obsession with death. Despite this sense of tragedy and darkness, English scholar Pollack-Pelzner (2020) recently argued that Shakespeare wrote his best works during the time of the plague, including *Macbeth* (1605–1606), *Antony and Cleopatra* (1606–1607), and the poem *Venus and Adonis* (1593). Similarly, McCouat (2015) argues that some artists who survived the plague in fact benefitted from the fewer number of creatives, such as the Sienese visual artist and painter Bartolo di Fredi. The current phase of creative destruction (as per Schumpeter, 2010) will unquestionably have a significant short to medium-term effect on current creative industries; the lasting effects are, to a large extent, only just beginning to emerge.

Although quantitative reports about global crises are critically important, such as the estimated deaths caused by past plagues and wars, or maps showing the epicentres and spread of various contagions, it is great artwork that leaves a rich and compelling long-lasting legacy, revealing the horrors, the devastation, and disruption, but also the hope, the imagined future, and the human strengths to emerge during such traumatic events. Creative works produced during crises are often

infused with gut-wrenching emotion as well as narratives that are as disturbing as they are informative, and they give audiences a visual, aural, and emotional connection to the time and the experience of those who fell victim to the relevant crisis or who managed to adapt and survive. One only need read Camus' *The Plague* (1947) or listen to Penderecki's *Threnody to the Victims of Hiroshima* (1960) in the cold dark of night to be moved, disturbed, and even traumatised to some extent, and to be reminded of the seriousness of the crisis of the time.

Art often possesses a futuristic or predictive nature as well. Jones (2020) recently suggested that some of the paintings by the American artist Edward Hopper in fact foretell the realities of the current pandemic, citing two works in particular which foreshadow the Covid-19 lockdowns, namely *Cape Cod Morning* (1950), with the woman in the painting exhibiting tension as she peers out of her window, and *Car Chair* (1965) which represents social distancing. Several films and film-makers in recent decades have also hinted at future realities, such as the cyber hacking seen in *War Games* (1983), self-driving cars in *Total Recall* (1990), a pandemic in *Contagion* (2011), or the concept of "big brother" in *Enemy of the State* (1998). Art not only documents the past and the present, but it has the capacity to propose and predict the future too; future generations will be able to engage with recently created work which depicts the current catastrophe that is Covid-19 and that may also point towards future realities.

Art and the Covid-19 Crisis

Many current high-profile artists have created new work either indirectly or directly linked to the Covid-19 pandemic, such as musicians Bob Dylan, Taylor Swift, and The Rolling Stones, as well as the elusive and controversial multimedia artist Banksy, and contemporary artists such as Angela Palmer with her work *2020: The Sphere that Changed the World* and David Goodsell with *Escherichia coli Bacterium* (2021). The time and space that shutdowns and lockdowns allowed became a vehicle for creativity and the completion of new work for many well-known artists. In addition to artists and their works which have garnered attention in the public discourse, millions of professional visual artists, musicians, performers, and creatives across a range of analogue and digital formats have and are producing new work in response to the pandemic. Face masks, social distancing, isolation and quarantine, domestic abuse, political issues, hopelessness, and hope are some of the main themes to influence these contemporary works.

The world saw murals, street art, and graffiti emerge quickly at the time of the outbreak of the pandemic (Anstett, 2020; Daniel, 2021; Lawrence & Shirey, 2023). Most of these were designed to communicate

messages about social distancing, the need to stay at home unless absolutely necessary, the health benefits of wearing face masks, the heightened risk of domestic violence during lockdowns, or the critical importance of hand washing. Lawrence and Shirey (2023) outline the development of an online database of Covid-19 street art from around the world, which is a "crowdsourced collection of more than five hundred individual records containing images of street art, including stickers, tags, light projections, murals" (p. 27). The database, which continues to grow, can be explored for the range of ways in which artists have created messages and reflections on the lived realities of the Covid-19 crisis.

Art as a powerful form of communication during Covid-19, be this via text, sound, or image, has already gained significant attention in the academic literature. This has been of critical importance in developing countries. For example, street art in Eastern Africa has been explored for its messages and qualities, and highlights the importance of art as a communication tool and for public messaging (McEwan et al., 2022). Also in Africa, Aikins and Akoi-Jackson (2020) describe how state-sponsored arts outputs such as murals and original songs in Ghana in 2020 provided important forms of health-related communication to the general public as the pandemic took hold.

In Canada, the government commissioned local musicians to create new works that communicated key messages relevant to the pandemic, believing that pre-existing high levels of engagement with music in general would mean there was to some extent a captive audience; the significant uptake of this new work by the general public may have influenced public perceptions relevant to surviving the pandemic (Cournoyer Lemaire, 2020). In the US, three African American artists collaborated with the dating app BLK to create a re-imagined version of the hugely popular *Back That Thang Up* (1999) to become *Vax That Thang Up* (2021), and which to date has had over 3.3 million views. This collaboration was designed specifically to communicate to the Black population the critical importance of Covid-19 vaccines, given the infection and mortality rates were considerably higher for this population group (Hawkins & Simon-Roberts, 2023).

In addition to high-profile musicians such as Bob Dylan, the current pandemic has prompted many other composers to write new work, such as the tongue-in-cheek *Coronavirus Etude for Piano and Disinfecting Wipe* (2020) by American musician Jeff DePaoli, the more melancholic works *Solidarity* (2020) by British composer Thomas Hewitt Jones and *Isotropes* (2020) by American Brian Baumbusch, the latter of which was first recorded by 40 individual musicians who were remote and isolated during lockdowns. Baumbusch's work also features the inclusion of breathing sounds as a direct tie to one of the complications caused by the

virus – shortness of breath and the subsequent feelings of anxiety, panic, and even impending mortality. Nat Bartsch, an Australian composer, crafted an album called *Hope* (2021) in response to both the devastating bushfires in Australia during the 2019–2020 summer and Covid-19; the album was intended to be cathartic in response to the prevailing hopelessness, as well as conveying a sense of hopefulness.

A number of creative minds have set out to use art to raise both awareness and urgently needed funds to support health services. Two in the UK stand out. One is the compelling visual artwork *Game Changer* (2020) by the elusive Banksy, which depicts a young boy playing with a superhero nurse figure; this work raised more than £16 million for the National Health Service. Another is the incredible contribution of nonagenarian Major Tom Moore, who walked 100 laps of his garden in 2020, which led to a music video version of the famous music track *You'll Never Walk Alone*. The video subsequently raised over £30 million for the UK National Health Service, and his efforts will likely be a contribution remembered by generations. There are countless other examples of how individuals and groups responded artistically in small and in major ways to the outbreak of the virus, creating new work or using existing work in new ways to give people some escape and solace, or using the arts to raise awareness and much-needed funds for health services and front-line workers.

Many artists in creative industries have a strong sense of social justice and ethics, as well as a desire to use art and creativity as a means by which to document, stimulate, and promote civic discourses and social critique, and to invite viewers, listeners, and readers to reflect, think, and, where appropriate, act in response to the relevant crisis at hand. The current pandemic has seen this broad humanistic agenda come through the arts in every nation. McGrath (2022) cites Taylor Swift's *folklore* (2020) album as an example of such creative work, with its strong environmental and fantasy aesthetic, sense of nostalgia, and "search for foundations during the pandemic" (p. 1) – including a way of dealing with not only the pandemic but the anxieties caused by climate change.

This humanistic concern and the importance of creative industries in a global crisis is also described by Giusti (2023) in relation to major cultural institutions, where "museums along with theatres, cinemas, concert halls, art galleries, and libraries have been valued as truly integral to public vitality and wellness and part of a broader cultural ecosystem that helps people and communities' resilience, recovery and possibly strength" (p. 5). Several museums have played an important part in the current crisis in terms of collecting both digital artefacts (e.g., oral stories) and tangible items (e.g., health-conscious clothing) as a way of working with their audiences and communities during such

a period of monumental uncertainty, and to preserve items that reflect this tumultuous time (Raved & Yahel, 2022).

Although it is too early to tell what creative artefacts produced since the outbreak of the pandemic in early 2020 will become iconic cultural works in the future, it is also the case that there will be thousands of new works yet to be conceptualised in response to Covid-19 and its ongoing impact on societies. The pandemic is now in its fourth year and shows no immediate signs of being completely eradicated, given the ongoing number of cases and deaths, as well as the prospect that other strains of the virus might emerge in the years ahead. What has changed in most nations is the relaxing of stringent policy settings and health directives, with societies accepting that although the pandemic will continue in some shape and form for the foreseeable future, it is better to return to some sense of normality, while maintaining efforts to adopt health protocols such as social distancing, mask wearing, and hand washing.

Whether artists and creatives respond to the human costs, the social impacts, or apply a future-focused lens, the current pandemic will stir the emotions, the creative spirit, the desire to uplift, and to generate positivity. The decade of the 2020s, with the pandemic, the war in Ukraine, deep-seated social injustices, rapid technological advances, and the grief and ongoing devastation caused by climate change, will continue to inspire and compel artists and creatives to document, to visualise, and to create narratives and sounds which become historical representations of this tumultuous time.

The Irony of Creative Industries during Global Crises

It is ironic that the current crisis and lockdowns around the world have led people to turn to the arts more than they may have previously. The irony or paradox (Bradbury et al., 2021) relates to the fact that creative industries are often criticised during relatively peaceful times for their drain on the public or private purse; their perceived contribution to society is often challenged and arguments are presented that there are far more important global priorities than investing in arts and culture. Yet the current pandemic has again reiterated the comfort, the solace, the escape, and the wellbeing that a great story, film, digital or analogue music album or series of images provides, as well as the comfort that people of all levels of expertise can enjoy when engaging in *everyday creativity*. This engagement could be doodling or sketching, writing a poem or short story, singing alone or with others, dancing in the kitchen, taking photographs to capture the beauty of nature, or starting projects with children and with communities.

For the millions who have suffered the loss of loved ones, been struck down by the virus, cared for family and friends, or lost work and career

opportunities, the arts have helped to ease pain and suffering, to heal, and to instil a sense of hope and positivity. As the esteemed social psychologist Simonton (2013) contends, during a time of crisis people rarely revisit or turn to a great work of the physical and human sciences such as tomes by Darwin, Galileo, or Freud, but they remember, re-engage, and carry with them the emotional, intellectual, aural, or visual stimulation and memories of a great Shakespeare play, a Beethoven symphony, a painting by Monet or Picasso, a captivating novel, a riveting rock concert, or an Academy Award-winning film. This engagement with art and creativity has no doubt helped billions through the Covid-19 pandemic and the various forms of trauma that it has caused.

Benefits from the Crisis for the Environment and for the Democratisation of Creative Industries

A distinct possibility and positive outcome amidst the devastation is that the world may see further reductions in carbon emissions and a boost to climate change awareness and targets as a result of the pandemic. Lockdowns and social distancing measures have forced generations to embrace working online both as individuals and groups; this has reduced the need for carbon-heavy travel to work and work-related events, significantly decreased the volume of air travel, and reduced the cost and environmental impact of cooling and heating large venues. Although the value of person-to-person interaction can never be replaced, the world can now pay serious attention to, and make decisions about, activities where working and collaborating online is as effective as being in-person. For example, is it absolutely necessary for world leaders and corporate executives to spend huge sums of money and push tonnes of carbon into the atmosphere in order to attend in-person meetings, conferences, or workshops for only a few days? The pandemic has proven that such meetings can be achieved using online technologies. These technologies are likely to improve exponentially in coming years, hence there is now a global imperative and opportunity to pay careful attention to the environmental costs associated with all activities, including those in creative industries.

In addition to the environmental benefits of the shift to online platforms and ways of working, the pandemic has opened up possibilities for people in any location to participate in online events, networking initiatives, and learning experiences. A music or theatre student living in a rural setting with limited exposure to the major global centres can now participate in coaching sessions or masterclasses with experts in the field, which prior to the pandemic would have involved prohibitive cost and time factors. Visual art students such as painters and sculptors can view established practitioners at work in virtual studio sessions, as well as

gain feedback on their personal practices via online peer networks and image-sharing technologies, and photographers can learn specialist skills via recently developed software platforms such as the studio simulation program set.a.light 3D, rather than have to be in a studio in person, and to hire models, stylists, and equipment – all of which can be prohibitively costly.

The now-ubiquitous use of virtual meeting spaces such as Skype, Zoom, and Microsoft Teams therefore raises key questions specific to the creative industries sector: what is the cost-time benefit or environmental impact of in-person experiences versus those in virtual settings? To what extent do the advantages achieved through virtual means, such as the democratisation of art and reduced environmental impact, outweigh any disadvantages? For those outside the major global centres and in the Southern Hemisphere in particular, the rapid shift to virtual platforms has helped bridge the North-South divide that has been a key structural issue in the creative industries field. The creative destruction (Schumpeter, 2010) that Covid has caused makes it clear that those in creative industries in privileged locations and positions arguably have a new ethical responsibility to work towards a more equitable, inclusive, and participatory creative industries sector for future generations that also engages in careful scrutiny and consideration of environmental factors and impact.

Government Support Initiatives for Creative Industries during Covid-19

Creative industries are often subjected to precarious government funding and policy environments (Barnett, 2022), with perhaps the exception of mainland Europe, where for centuries arts and culture are seen to be crucially important to national, state, and individual identity. Aside from Shakespeare and other writers from the UK such as Byron, Beckett, and Plath, it is mainland Europe that has arguably seen the majority of the world's greatest artists. One need only think of Bach, Mozart, Hildegard, Beethoven, Debussy, Stravinsky, Michelangelo, da Vinci, Vermeer, Picasso, Munch, Monet, Tolstoy, Dostoyevsky, and Kafka as evidence of this. As we move into the 20th century, the field certainly broadens to include non-European greats such as Kahlo, Pollock, Beach, Gershwin, Glass, Angelou, Miller, Dickinson, Takemitsu, and Elgar; despite this, artists from the European continent and writers from the UK have formed the core of the great artistic canon.

In the 21st century, mainland Europe – more so than any other geographical region – continues to value and support the arts as the backbone of culture, identity, and intellectual endeavour. In other parts of the world, such as the US, the UK, Australia, and New Zealand, creative industries

have been subject to the whim of frequently changing governments and cultural policy settings, neoliberal ideologies, and an increasing focus on metrics and value-based propositions (Jeannotte, 2021). The ongoing creative destruction caused by Covid-19 and subsequent massive rise in global debt is a further threat to creative industries, with governments looking to implement what may be even more severe austerity measures in future years to deal with rising debt levels.

There are two aspects to the ways in which governments responded to the Covid-19 outbreak and its impact on creative industries. One was the establishment of immediate relief funds, the other a review of existing cultural policies to ensure creative industries were best placed for economic recovery. In some circumstances, urgent revisions to creative industries policy were identified as necessary and therefore enacted quickly (Betzler et al., 2021). Most developed countries allocated direct funds to support creative industries as soon as practically possible, although these tended to be for large organisations and cultural institutions and their workers (both artists and support staff), more so than independent or freelance creatives and those in community arts areas.

Although the exact nature of the timing of the rollout of rescue packages for creative industries is somewhat grey, Yue (2022) contends that "by the end of March [2020], about 54 countries had provided emergency support to the arts" (p. 353). Where policy review occurred, in some cases this highlighted gaps and the challenge of determining how policy would best support creative industries towards economic recovery and growth. For example, Langevang et al. (2022) argue that the pandemic has again highlighted how creative industries policies are, in general, "inadequate in terms of providing effective regulation and protection for creative workers" (p. 143).

Although rescue packages for creative industries were established in many countries worldwide, some countries were quick to respond and others less so (Reason et al., 2022), resulting in a situation where, while some governments "led and offered substantial and robust measures, others dragged their feet, or failed to provide any kind of targeted aid at all" (Banks & O'Connor, 2021, p. 6). Despite several early stumbles and failed lobbying exercises, by mid-2020 the UK government set aside £1.57 billion in a cultural recovery fund, and leaders in the sector were tasked with the responsibility of positioning their organisation or institution to access this support in what Eastell (2022) refers to as an emergency leadership mode. In the US, the government allocated US $135 million of emergency funding for the sector, the Singapore government set aside S$55 million in an arts and culture resilience package, and the New Zealand government was lauded for its quick response and allocation of NZ$175 million to arts and culture (Pacella et al., 2021). Most European countries provided immediate packages of funding

relief, while some of the world's leading city centres for creative industries such as Berlin and New York also put in place specific financial rescue or support schemes.

Some countries certainly appear to have outshone others in their immediate response to the crisis. Mangset et al. (2023) argue that policy settings in Norway during the pandemic provided more support for artists than in most other countries, while also citing Ireland and France as putting in place strong policy settings and support packages. In their study, Betzler et al. (2021) look at policy measures in the early days of the Covid-19 outbreak in the Czech Republic, the Netherlands, Portugal, Slovenia, and Switzerland. They look at specific responses across areas including tax, employment, stimulus programs, and strategies specific to the creative and cultural industries. At the time of writing, they identify proactive measures in all selected countries with the exception of Slovenia, and with the wealthier countries (i.e., the Netherlands and Switzerland) investing larger sums than others.

Although immediate responses were welcomed in the sector, freelance artists and community arts were often not part of emergency policy and fiscal strategies or were ineligible for such schemes. For example, Jacobs et al. (2022) describe how community arts were often left behind in terms of both urgent policy responses and funding schemes, citing issues in Australia, Ireland, and Mexico. Shaughnessy et al. (2022) and Canham (2023) discuss how freelance artists with precarious and vulnerable work patterns – in comparison to salaried workers – were often neglected in Covid-19 rescue packages or policy settings. Emergency funding measures also drew attention to gaps in policy, with Pekkarinen et al. (2022) referring to this occurring in such countries as Finland, which has typically been regarded as having a stable arts and culture sector. Although gaps were identified, Pekkarinen et al. also cite important strategies put in place in Finland as an emergency response to the pandemic.

Australia, one of the most resource-rich and wealthy nations in the world, fares poorly in comparison to the Covid-19 recovery measures put in place in both northern centres for creative industries and its southern neighbour, New Zealand (Pacella et al., 2021). Harris (2022) is scathing in her attack on the stop-start nature of arts and cultural policy in Australia, and for the tokenistic and small sums of money dedicated to creative industries during the outbreak of the pandemic, in comparison to Ireland, Iceland, and measures implemented in cities such as Berlin and New York. She and others (Pennington & Eltham, 2021) refer to decades of funding cuts to arts budgets in Australia, and argue a series of policy failures and short-sightedness by the relevant political parties in power, with responses to the pandemic slow and problematic for creative industries. This dragged-out and tokenistic response further stressed an already under-funded creative industries sector, OECD data evidencing

the fact that in 2019 – just prior to the pandemic – Australia ranked 24th out of 29 countries in terms of its investment in creative industries as a percentage of GDP (OECD iLibrary, 2023).

The pandemic has emphasised the need for ongoing policy reform across a range of areas relevant to creative industries (Yue, 2022), including tertiary education for artists and creatives (Pennington & Eltham, 2021; Sabol, 2022). It has also highlighted the absence of policy specifically for creative industries in some countries. Lee et al. (2022) examined policy responses to the pandemic in South Korea, Japan, and China; they highlight the rapid changes and policy attention arts and culture received in South Korea and Japan at the time of the outbreak of the virus, but they describe a very locked-in policy setting and top-down approach in China, thereby resulting in minimal change. Crosby and McKenzie (2022) refer to the need to pay more attention to demand-side policies and not just supply factors, and Yan (2022) urges policymakers "to take the long view and understand the driving forces shaping the world we live in" (p. 65), especially the unknowns associated with the longer-term impacts of the current pandemic.

Rapid shifts to digital platforms for both creation and consumption means that future policy revisions and directions need to accommodate the digital and online environments in a more measured and deliberate manner (Snowball & Gouws, 2022). Holcombe-James et al. (2022) refer to the digital transformations that occurred during early lockdowns, hence cite the need for future arts policy to cater to the additional re-sourcing required, most notably in terms of infrastructure and labour costs. Similarly, Hylland et al. (2022), in their policy research relevant to seven European countries (Croatia, UK, Germany, Norway, Spain, Sweden, and Switzerland) argue that the pandemic did not accelerate revisions to the digital aspects of cultural policy in these nations despite significant shifts in the market to digital consumption of creative product. On the other hand, a clear policy focus on digital practices took place in Singapore in the early part of the pandemic, with policy settings focusing on supporting artists to develop digital skill capabilities, for example, to transfer content to digital platforms or create videos to boost their social media presence, and to provide professional develop-ment opportunities in a range of areas of both the business side of the creative industries as well as creative skills development (Yue, 2022).

There are also policy implications for other key stakeholders in the creative industries sector. For example, Radermecker (2021) argues for a strong focus on the consumer and consumer research in order to assist in the recovery process, given the implications and new imperatives for policy. Jacobs et al. (2022) present the case for a reset of policy in terms of the community arts and the artist-educator space, in terms of "moving away from capitalist, competitive and even philanthropic funding that

turns art into monetized and privatized purchase" (p. 32). They argue that it is imperative that policymakers in a post-pandemic world should work against any sentiments to return to pre-pandemic normal structures and frameworks, instead calling for systematic change which they aptly describe in the following analogy:

> The narratives here reflect the need to break or discard old structures, rather than remake and reform them. The tentacles of Eltahawy's[1] octopus that infect the world through capitalism, rampant neoliberalism, ableism, systemic racism, patriarchal structures, homophobia, [autocratic governance] and ecocide have proved they will not crumble willingly. (Jacobs et al., 2022, p. 36)

Emergency and ongoing policy and funding responses to the pandemic across all economic sectors will have long-term impacts for the global economy, given global debt levels have increased significantly and, in some countries, are approaching record levels; the US as recently as late May 2023 again had to endorse and sustain a debt ceiling of approximately US$34 trillion. In addition to the ongoing costs of managing the pandemic, many Western nations have set ambitious climate change targets that incur significant investment costs, and similarly many have contributed vast sums of money to Ukraine for their war efforts and resistance to the Russian invasion. The financial debts borne by countries around the world since 2020 will likely mean further austerity measures will be required, which will affect creative industries as well as tertiary education for creatives and artists (Sabol, 2022).

The recent discourse relevant to creative industries policy has also seen critique of the emphasis on resilience needed in the sector, and the increasing tendency for neoliberal government ideologies to place the responsibility on creative industries workers. A recent highly critical view is that "those who cannot bounce back from adversity have themselves to blame because of their failure to cultivate their own resilience" (Resario et al., 2023, p. 2). Resario et al. (2023) proceed to argue that ongoing austerity measures mean that policy needs to be directed at sustainable interventions, rather than simply how to withstand shocks; however, they highlight how there is a sense of blame-shifting to individuals amidst the crisis caused by Covid-19. As cited in the Introduction to this text, Adelman (2021) contends that the emphasis should be less focused on the deficit-oriented concept of *resilience*, and more towards the *endurance* that creative industries participants sustain

as the crises of the 2020s continue to affect the world. These policy and ideological debates are likely to continue for some time.

Conclusion

This chapter has highlighted how creative industries play a critical role during times of crisis, and that societies gain comfort and solace from creativity during periods of great catastrophe and trauma. Some of the greatest creative artefacts in history can be linked to periods of intense turmoil and tragedy. Covid-19 is the latest global crisis to have had a devastating human cost and it has placed countries around the world in positions of considerable stress, which will be ongoing for the foreseeable future – both in terms of the ongoing impacts of the virus and the disruptions to most areas of society. Although it is too early to tell what creative artefacts will emerge from the current crisis as great works of the time, it is through engagement with creativity, be this in small and everyday ways, in new ways, or at an increased level during lockdowns in general that has brought people some relief from trauma, loss, and hopelessness. People interact with creativity more than they perhaps realise during the bright times; the value of creativity and of art becomes heightened and more present in people's minds during difficult times.

Policy also has a significant role to play for creative industries moving forward. Whether these are strong and supportive policies, to those with minimal or even nil support for creative industries, it is imperative that governments and cultural leaders look to their respective creative industries structures, and work together towards future-focused policy, particularly given the shifts in creative industries to digital spaces and experiences. The absence of effective policy settings in some countries is a major concern for creative industries, hence the current disruptions represent an opportunity for the sector to advocate for new or revised policies as appropriate to the 'new normal', and as the world continues to emerge from the current pandemic crisis.

Despite the tremendous losses caused by Covid-19 (and it has to be recognised that it has not yet ended in terms of diagnosed cases and mortalities), there are positives to emerge from the ashes, given creative industries "will return, will adapt and respond and rejuvenate" (Reason et al., 2022, p. 540). Participation in creativity has been further democratised, and geographic borders and the North-South divide have been softened due to shifts from in-person experiences of creativity to online and virtual spaces, buoyed by an understanding within the sector that collaboration and cross-sector support is vital. The creative industries sector has the opportunity to continue to revisit how it might further contribute to the climate change agenda, to fight

for policy change and greater government recognition, and to fine-tune the methods and data sources used to demonstrate its value and impact. From great storms, new growth emerges, and in terms of creative industries, this will lead to a revitalised landscape of words, images, sounds, and aesthetic experiences. Creative industries will bloom again, and there is much to look forward to as to what this new landscape brings to a world seeking refuge and solace, and to a brighter future worldwide.

Note

1 Jacobs et al. (2022) explain that "Egyptian born feminist, activist, journalist and writer, Mona Eltahawy, uses the metaphor of an octopus to illustrate various forms of oppression that maintain order" (p. 31).

References

Adelman, R. (2021). Enduring COVID-19, nevertheless. *Cultural Studies, 35*(2–3), 462–474. 10.1080/09502386.2021.1898014

Aikins, A., & Akoi-Jackson, B. (2020). "Colonial virus": COVID-19, creative arts and public health communication in Ghana. *Ghana Medical Journal, 54*(4s), 86–96. 10.4314/gmj.v54i4s.13

Anstett, C. (2020). Artists in the streets: Seattle murals in the time of COVID-19. *The Journal of Public Space, 5*(3). 10.32891/jps.v5i3.1414

Arai, T. (2023). Exposed in a hundred suns. https://takashiarai.com/exposed-in-a-hundred-suns/#ms-357

Bach Cantatas. (2023, March 20). Cantata BWV 25. Es ist nichts gesundes an meinem leibe [There is nothing sound in my body]. https://www.bach-cantatas.com/Texts/BWV25-Eng3.htm

Banks, M., & O'Connor, J. (2021). "A plague upon your howling": Art and culture in the viral emergency. *Cultural Trends, 30*(1), 3–18. 10.1080/09548963.2020.1827931

Barnett, T. (2022). Covid-19. In M. Reason, L. Conner, K. Johanson, & B. Walmsley (Eds.), *Routledge companion to audiences and the performing arts* (pp. 418–423). Routledge. 10.4324/9781003033226

Betzler, D., Loots, E., Prokůpek, M., Marques, L., & Grafenauer, P. (2021). COVID-19 and the arts and cultural sectors: Investigating countries' contextual factors and early policy measures. *International Journal of Cultural Policy, 27*(6), 796–814. 10.1080/10286632.2020.1842383

Bland, A. (2023, January 12). Haiti crisis: How did it get so bad, what is the role of gangs, and is there a way out? *The Guardian*. https://www.theguardian.com/world/2023/jan/12/haiti-crisis-jovenel-moise-gangs-water-way-out

Bradbury, A., Warran, K., Mak, H., & Fancourt, D. (2021). *The role of the arts during the COVID-19 pandemic*. University College London. https://discovery.ucl.ac.uk/id/eprint/10159116/1/Arts%20during%20covid-19%20ACE%20report.pdf

Bruegel, P. (1562–1563). *The triumph of death* [oil on panel]. Madrid, Spain: Museo del Prado. https://tinyurl.com/bdpbv4p8

Canham, N. (2023). Living with liminality: Reconceptualising music careers education and research. *Research Studies in Music Education, 45*(1), 3–19. 10.1177/1321103X221144583

Cournoyer Lemaire, E. (2020). Extraordinary times call for extraordinary measures: The use of music to communicate public health recommendations against the spread of COVID-19. *Canadian Journal of Public Health, 111*(4), 477–479. 10.17269/s41997-020-00379-2

Crosby, P., & McKenzie, J. (2022). Survey evidence on the impact of COVID-19 on Australian musicians and implications for policy. *International Journal of Cultural Policy, 28*(2), 166–186. 10.1080/10286632.2021.1916004

Daniel, R. (2021). The arts as a form of comfort during the COVID-19 pandemic. In V. Bozkurt, G. Dawes, H. Gulerce, & P. Westenbroek (Eds.), *The societal impacts of COVID-19: A transnational perspective* (pp. 109–121). Istanbul University Press. 10.26650/B/SS49.2021.006.08

Eastell, C. (2022). The future of cultural leadership. In M. Witzel (Ed.), *Postpandemic leadership: Exploring solutions to a crisis* (pp. 156–168). Routledge. 10.4324/9781003171737

Giusti, S. (2023). Museums after the pandemic, from resilience to innovation: The case of the Uffizi, *International Journal of Cultural Policy*, 1–14. 10.1080/10286632.2023.2167986

Harris, L.C. (2022). How neoliberalism swallowed arts policy. *Kill Your Darlings*, 113–120. https://search.informit.org/doi/10.3316/informit.673930269874154

Hawkins, D., & Simon-Roberts, S. (2023). Music videos as health promotion: Juvenile's "vax that thang up" and the promotion of the COVID-19 vaccine in the Black community. *American Behavioral Scientist*. 10.1177/00027642221145027

Higgins, C. (2023, May 10). Pass the paint and mind the shrapnel: Inside Ukraine's most creative bomb shelter. *The Guardian*. http://bit.ly/3ptamyi

Holcombe-James, I., Flore, J., & Hendry, N. (2022). Digital arts and culture in Australia: Promissory discourses and uncertain realities in pandemic times. *Media International Australia*. 10.1177/1329878X221136922

Hylland, O., Burri, M., Lindblad Gidlund, K., Handke, C., Rodríguez Morató, A., Oakley, K., Primorac, J., & Uzelac, A. (2022). Pandemic cultural policy. A comparative perspective on Covid-19 measures and their effect on cultural policies in Europe. *International Journal of Cultural Policy*, 1–20. 10.1080/10286632.2022.2154342

Jacobs, R., Finneran, M., & Quintanilla D'Acosta, T. (2022). Dancing toward the light in the dark: COVID-19 changes and reflections on normal from Australia, Ireland and Mexico. *Arts Education Policy Review, 123*(1), 29–38. 10.1080/10632913.2020.1844836

Jeannotte, M.S. (2021). When the gigs are gone: Valuing arts, culture and media in the COVID-19 pandemic. *Social Sciences & Humanities Open, 3*(1), 100097. 10.1016/j.ssaho.2020.100097

Jones, J. (2020, March 28). 'We are all Edward Hopper paintings now': Is he the artist of the Coronavirus age? *The Guardian*. https://tinyurl.com/yeykvuyx

Judt, T. (2001). Introduction. In A. Camus (Ed.), *The plague* (pp. vii–xvii). Penguin press.

Langevang, T., Steedman, R., Alacovska, A., Resario, R., Kilu, R., & Sanda, M. (2022). 'The show must go on!': Hustling through the compounded precarity of

Covid-19 in the creative industries. *Geoforum, 136*, 142–152. 10.1016/j.geoforum. 2022.09.015

Lawrence, D. T., & Shirey, H. (2023). Spreading through the streets: The COVID-19 street art database. *Journal of Folklore Research, 60*(1), 27–42. https://www. muse.jhu.edu/article/886958

Lee, H., Ling-Fung Chau, K., & Terui, T. (2022). The Covid-19 crisis and 'critical juncture' in cultural policy: A comparative analysis of cultural policy responses in South Korea, Japan and China. *International Journal of Cultural Policy, 28*(2), 145–165. 10.1080/10286632.2021.1938561

Mangset, P., Kleppe, B., & Heian, M. (2023). Artistic careers and crises. How did the pandemic affect Norwegian artists? *Cultural Trends.* 10.1080/09548963. 2023.2167067

McCouat, P. (2015). Surviving the Black death. *Viitattu, 3*, 2021. https://www. artinsociety.com/surviving-the-black-death.html

McEwan, C., Szablewska, L., Lewis, K., & Nabulime, L. (2022). Public-making in a pandemic: The role of street art in East African countries. *Political Geography, 98*, 102692. 10.1016/j.polgeo.2022.102692

McGrath, J. (2022). The return to craft: Taylor Swift, nostalgia, and Covid-19. *Popular Music and Society, 46*(1), 70–84. 10.1080/03007766.2022.2156761

Meiss, M. (1973). *Painting in Florence and Siena after the Black death: The arts, religion and society in the mid-fourteenth century.* Harper and Row.

OECD iLibrary. (2023). 5. Public and private funding for cultural and creative sectors (figure 5.1). https://www.oecd-ilibrary.org/sites/29f05369-en/index.html? itemId=/content/component/29f05369-en

Pacella, J., Luckman, S., & O'Connor, J. (2021). Fire, pestilence and the extractive economy: Cultural policy after cultural policy. *Cultural Trends, 30*(1), 40–51. 10.1080/09548963.2020.1833308

Pekkarinen, J., Siltanen, K., & Virkkala, M. (Eds.). (2022). Reconstruction of the arts sector: Roadmap for a sustainable future. *Uniarts Helsinki.* https://taju. uniarts.fi/handle/10024/7625

Pennington, A., & Eltham, B. (2021). Creativity in crisis: Rebooting Australia's arts and entertainment sector after COVID. *The Centre for Future Work at the Australia Institute.* https://apo.org.au/node/313299

Pollack-Pelzner, D. (2020, March 14). Shakespeare wrote his best works during a plague. *The Atlantic.* https://www.theatlantic.com/culture/archive/2020/03/ broadway-shutdown-could-be-good-theater-coronavirus/607993

Radermecker, A.S. (2021). Art and culture in the COVID-19 era: For a consumer-oriented approach. *SN Business & Economics, 1*(4). 10.1007/s43546-020-00003-y

Raved, N., & Yahel, H. (2022). Changing times – A time for change: Museums in the COVID-19 era. *Museum Worlds, 10*(1), 145–158. 10.3167/armw.2022. 100111

Reason, M., Conner, L., Johanson, K., & Walmsley, B. (Eds.). (2022). Routledge companion to audiences and the performing arts. *Routledge.* 10.4324/9781003 033226

Resario, R., Steedman, R., & Langevang, T. (2023). Exploring everyday resilience in the creative industries through devised theatre: A case of performing arts students and recent graduates in Ghana. *International Journal of Cultural Studies.* 10.1177/13678779231163606

Sabol, F. (2022). Art education during the COVID-19 pandemic: The journey across a changing landscape. *Arts Education Policy Review, 123*(3), 127–134. 10.1080/10632913.2021.1931599

Schumpeter, J. (2010). *Capitalism, socialism and democracy.* Routledge.

Shaughnessy, C., Perkins, R., Spiro, N., Waddell, G., Campbell, A., & Williamon, A. (2022). The future of the cultural workforce: Perspectives from early career arts professionals on the challenges and future of the cultural industries in the context of COVID-19. *Social Sciences & Humanities Open, 6*(1), 100296. 10.1016/j.ssaho.2022.100296

Simonton, D. (2013). Creative genius in literature, music, and the visual arts. In V. Ginsburgh, & D. Throsby (Eds.), *Handbook of the economics of art and culture* (Vol. 2, pp. 16–43). Elsevier. 10.1016/B978-0-444-53776-8.00002-7

Snowball, J.D., & Gouws, A. (2022). The impact of COVID-19 on the cultural and creative industries: Determinants of vulnerability and estimated recovery times. *Cultural Trends*, 1–24. 10.1080/09548963.2022.2073198

Snowden, F.M. (2019). *Epidemics and society: From the Black death to the present.* Yale University Press. 10.2307/j.ctvqc6gg5

UNESCO. (2015). "Saving the cultural heritage of Iraq" – Director-general welcomes adoption of the UN general assembly resolution. https://whc.unesco.org/en/news/1287

Unsworth, N. (2022). *Untitled.* [Digital photograph]. https://nigelunsworth.smugmug.com/Europe

Yan, Y.C. (2022). The role of culture in the post-pandemic world. *Cultural Connections, 7.* https://www.mccy.gov.sg/cultureacademy/researchandpublications/journals/Cultural-Connections-Vol-7

Young, M. (2022). Saving the artwork of Ukraine. *The Wilson Quarterly.* https://www.wilsonquarterly.com/quarterly/ripples-of-war/saving-the-artwork-of-ukraine

Yue, A. (2022). Conjunctions of resilience and the Covid-19 crisis of the creative cultural industries. *International Journal of Cultural Studies, 25*(3–4), 349–368. 10.1177/13678779221091293

2 The Impact of Covid-19 on Arts Audiences

In addition to the massive shock the initial outbreak of the pandemic caused for artists, arts and cultural institutions, and the broader creative industries sector, audiences and consumers of creative content were deeply affected in relation to their engagement with creativity, in both negative and positive ways. Activities in venues that audiences relished and relied on for socialising, for intellectual stimulation, or for having a concentrated period away from the stressors of life and to be immersed in a creative space were gone. Lost were such typical activities as a gallery or museum experience; attendance at an art fair, festival, or popular music concert; in-venue cinema experiences; attendance at a live symphony orchestra, opera, ballet, contemporary dance, or circus performance; or engagement with such activities as artist talks, workshops, reading groups, conferences, or demonstrations.

The loss of these in-person experiences was felt deeply around the world. This loss even extended to pre- and post-event coffees, drinks, and discussions, which for many was a great form of socialisation and connection. A core part of peoples' lives was taken away and at the time of initial lockdowns, the outlook was grim as to when there would be a return to normal in-person experiences. The usual audience patterns of in-person consumption of arts and culture were subject to serious creative destruction (as per Schumpeter, 2010), and for performing artists in particular, the loss of the live performer-audience-performer experience and interaction was seen as especially challenging (Vincent, 2022). Performing in empty performing arts venues proved to be a major mental challenge for many artists and creatives.

Despite this loss, there were positives to emerge for audiences as a consequence of the pandemic, with lockdowns accelerating innovations in the way producers and managers of creative content presented their work beyond in-person experiences, which aligns to theories of audience experience innovation (White, 2023). Producers and managers of online content experimented with ways to "nurture the relationship with

DOI: 10.4324/9781003434603-3

audiences" (Brilli et al., 2022, p. 1). The rapid shift to online platforms offered audiences access to a raft of new material from the comfort of their own home; the ability to avoid potential exposure to the virus in both outdoor and indoor spaces; nil or lower ticketing costs; and for those with a strong environmental conscience, the ability to reduce their personal carbon footprint.

This shift did however result in complex consequences for the producers and hosts of creative content (Reason et al., 2022). For some artists such as writers, composers, designers, and digital artists, work patterns were, in general, minimally affected by having to work from home. On the other hand, those with strong performative, in-person, or outdoor practices, such as musical groups, actors, dancers, 3D and landscape artists, and photographers, were faced with a different set of challenges (Skaggs et al., 2023). For example, dancers were faced with the prospect of having to find sufficient space in the home to rehearse alone and then in groups via software such as Zoom (Brilli et al., 2022). Photographers accustomed to studio shoots or field work had to look to alternative sites of image capture and creation. Festivals with significant performing arts elements faced complications associated with shifting live and in-person performance rituals and interactions to online platforms (Piccio et al., 2022).

A major positive factor for audiences when out of lockdowns was the emergence of public events such as ad-hoc or planned dance performances in streets and parks, invitations to join participatory events such as an informal performance of a well-known music work in an open space, or the presentation of visual artforms in both analogue and digital forms, such as video projections on buildings or temporary exhibits of visual works in pop-up style formats. These outdoor events enabled audiences to socially distance and to be free to move in and out of the performance or display areas as they deemed necessary. The emergence of high-quality murals and graffiti art in many countries created the opportunity for audiences to pause, to reflect, and to engage in conversations with fellow citizens about the work and its message(s), or about their individual experiences of lockdown. These visual artefacts also provided audiences with an opportunity to find comfort, humour, distraction, and even inspiration during periods of intense stress, loss, and uncertainty, while out of the home and in public areas.

The pandemic meant that creative content suddenly had a much stronger public and outdoor presence when regions were not in periods of lockdown (Sargent, 2021). Audiences could determine almost every aspect relevant to these new live experiences, including the time they would spend in these locations, the health protocols they were comfortable with (e.g., mask wearing and social distancing), and how often they might return to a location if work was in situ for an extended period

of time. A caveat to this silver lining was again in terms of access and equity; people living with a physical disability or mental health condition could not easily join this new type of audience setting or experience without significant and often prohibitively costly support measures.

Despite these complex issues and the rapid pace of change for audiences and performers, the pandemic meant a brave new world in terms of engagement with creative content in public settings, and a future which would be very unlikely to see a return to pre-pandemic and in-house audience experiences and practices as the sole mode for audience participation. It is argued that post-pandemic creative industries will need to adopt a hybrid model of audience engagement, in terms of both in-person and online experiences, each of which has positives and negatives for audiences and the creators of work (Vincent, 2022).

In line with the policy support measures and rescue packages implemented in many countries around the world, lockdowns meant arts audiences had to shift their engagement with creative industries to online and streaming formats. This uptake by audiences was seen to be relatively successful (Yue, 2022); although necessary and logical, it did require that audiences embrace new ways of engaging with creative content and in some situations, to purchase these experiences. Creative industries institutions and artists responded as quickly as possible in shifting content online, resulting in what Damodaran (2022) refers to as a "massive surge in the use of virtual platforms" (p. 209). Major institutions such as the "Paris Opera, the Royal Opera House UK, the New York City Ballet, and the Mariinski Theatre at St Petersburg launched ambitious programs for streaming their best ballets, orchestra, and opera performances across the world" (Damodaran, 2022, p. 218).

In China, the implementation of premium video-on-demand platforms created new patterns of consumption and became a "dominant global trend" (Yue, 2022, p. 355), with similar initiatives occurring in such nations as Korea, Australia, and Indonesia (Yue, 2022). According to De Peuter et al. (2023), there was "massive expansion in video streaming and digital gaming" (p. 377) amongst the global middle classes. In India, the highly successful dance application Avonya came to prominence in 2021, and which was a platform by which users could purchase online tutorials in traditional Indian dance (Basu, 2023). Numerous consultancy-type companies such as Patternmakers (Australia), TRG Arts (International), and The Audience Agency (UK) had an increasingly prominent role, with strategies that included exploring the ways in which cultural institutions and organisations could grow their virtual or online audiences. These consultancy groups continue to work with creative industries organisations who wish to cater to this new era in creator-audience relationships and forms of engagement.

Although access to high-quality online creative content was a boon for global audiences, it again highlighted issues around access to arts and culture for those without the necessary digital infrastructure and financial resources to support this type of engagement. Those without the necessary hardware and software, those with limited digital skills and literacies, or those with problematic or even no connectivity to digital networks were unable to engage in the same way as more privileged audiences.

Patterns of Audience Engagement: Early Research Studies

The shift to online, virtual, and at-home experiences of creative industries has already garnered significant research attention, with numerous national arts councils, funding bodies, arts advocacy groups, and academics engaging in systematic research exercises in relation to this new landscape for creative industries – many with a strong focus on audiences and citizens (Sargent, 2021). For example, Mak et al. (2021) gathered data from a sample of 19,384 participants based in the UK and found that the main arts activities during lockdowns were "digital arts and writing, musical activities, crafts, and reading for pleasure" (p. 10). They established that those in the younger demographic (age 18–35) were more likely to increase their engagement with art during lockdowns (22%), while the majority maintained their existing engagement (62%). Conversely, those with experiences of abuse or who had strong avoidance coping strategies in fact decreased their engagement with art and arts-based activities (16%). However, Mak et al. (2021) found that in general the arts helped people manage their emotions during these periods of peak stress.

Another study focused on music involved 1,868 survey participants in Spain, revealing that during lockdowns there was an increased engagement in such activities as singing, dancing, and playing a music instrument, which also helped participants' wellbeing (Cabedo-Mas et al., 2021). In Australia, the peak funding body for the arts, the Australia Council, presented the findings of a survey involving 23,000 respondents. The survey identified that during lockdowns, the majority (75%) participated in online arts and culture activities such as viewing online content and live-streamed events, or participating in arts-based online classes or tutorials (Barnett, 2022).

In a small study involving 486 participants, the majority of whom were based in the US (over 90%, median age = 35.7 years), Drake et al. (2022) found that this group engaged with the arts more than they had done so prior to the pandemic. Listening to music was the most frequent activity, followed by reading and visual arts activities, with this engagement with art and artmaking enabling participants to find a means

of escape from the stressors caused by the pandemic and lockdowns, as well as assisting with regulating their emotions, similarly to the study by Mak et al. (2021) cited previously. Selen et al. (2023), in a study involving 627 survey participants in Turkey, identified that one-quarter of participants (25.71%) found that the shift to online experiences of gallery exhibitions and artwork lacked an emotional element and was thus inferior to physical visits, 52.6% were neutral, and 29.6% favoured the online experience compared to in-person visits.

Although the shift to digital and in-home experiences did to some extent further democratise arts and culture for those previously excluded from various types of engagement due to cost, logistics, or health conditions preventing them from attending public events in particular, it was not necessarily uniform across societies. In what the authors refer to as "one of the world's largest investigations into the impacts of Covid-19 on the cultural industries" (Walmsley et al., 2022, p. 4), research evidenced that in the UK the pandemic aggravated and accelerated inequalities in the creative industries sector, including the lack of opportunity for marginalised groups to make the shift to online arts and culture, due to infrastructure requirements as well as initial and ongoing costs. Also in the UK, Bradbury et al. (2021) identified complexities such as "unequal digital access, difficulties reaching certain groups such as those shielding, obstacles to co-production, safeguarding concerns and technical challenges" (p. 5) as being relevant during lockdown periods in particular. They point to the prospect that patterns of audience engagement postpandemic will certainly be different to those prior to lockdowns, hence argue for detailed research in terms of policy settings, access, usage, and perceptions of online and virtual experiences including growth patterns and opportunities for user participation.

Although there has already been a flurry of research activity in government departments, arts organisations, and academic institutions in terms of how the sector has coped to date, authors such as Mak et al. (2021) and Drake et al. (2022) highlight the need for a significant body of ongoing research related to audience engagement with creative industries as the pandemic eventually subsides. These and other authors point to the fact that audience engagement patterns have changed and will continue to shift in coming years as the creative industries sector resets and rebuilds.

Changing Platforms for the Presentation of Creative Content

As a direct consequence of the shutdown of in-person experiences around the world, producers of creative content moved rapidly to convert or shift material to online platforms, be this through their existing web presence, through popular channels for creative content such as

YouTube, Twitch, Vevo, Vimeo, Spotify, and Apple Music, or via social media platforms such as TikTok, Instagram, and Facebook. Many of the world's large arts institutions (such as performing arts centres, galleries, and museums) invested heavily in technologies including augmented and virtual reality, in order to maintain connections with their existing audiences and to enhance in-person experiences outside of lockdowns (Damodaran, 2022). Museums looked to this new digital environment as a way in which to attract new and more diverse audiences (Giannini & Bowen, 2022), as did some individual artists who set out to shift their work online, be this through using still or moving images, text, audio files, or presentations such as pre-recorded artist talks or virtual studio visits and tours.

Many institutions already had a significant resource base of archived material in both analogue and digital forms, such as galleries who had considerable numbers of artworks in 2D, 3D, and digital forms. For some organisations this meant the rapid creation of digital versions of work for presentation online. Performing arts organisations, who had accumulated years of recordings, worked rapidly to find ways to move their material onto digital platforms and determine if and how any economic return could be achieved. Organisations with an international reputation and significant resource base were more readily able, however, to capture online and paying audiences than smaller institutions who often operated with minimal resources (Reason et al., 2022).

Indeed, the shift to digital platforms was a far more complex and resource-intensive task for the majority of individual artists and smaller arts organisations, who either did not have the digital infrastructure to support this shift, or lacked the necessary expertise and resources to effect this in a timely and relatively cost-efficient way, and to sustain this shift moving forward. Individual artists in particular had to reflect deeply on the extent to which they felt their work could be adequately represented on digital platforms, or whether they felt that in-person experiences were to be the primary method of audience engagement with their work, thereby deciding to pause the presentation of their work during lockdowns and look towards a return to in-person experiences. Some found a middle ground, building their social media presence and connections with audiences during lockdowns, creating excitement about new work being developed, but retaining the presentation of finished creative works for in-person situations such as exhibitions or performances.

The establishment of income-producing methodologies for these new digital offerings (e.g., live-streaming of an opera performance) was a major issue for the creative industries sector to address, in order that institutions, organisations, and individual artists could find some means by which to offset the high costs of quality streaming and other online

experiences, and ideally to make a profit. Audiences had to be encouraged and even educated to accept that a user-pay system for online content was similar to ticketing at in-house venues. Some creative industries participants instead opted to use online methods purely to stay connected to their audiences and to offer hope and healing during the crisis. For many institutions and individual artists, this was a new era for working with and for audiences.

Audience and User Patterns: Early Statistics

The territory and data surrounding the shift to online content and changing patterns of audience engagement are complex; nevertheless, there are some preliminary findings that have been determined in research and reporting. Although lockdowns did lead to increased engagement with online platforms for creative content, Sim et al. (2022) found that for Spotify – which recorded an increase in subscribers during lockdowns – its usage rates in fact declined, largely as a consequence of the fact that millions around the world were not undertaking commutes to and from work, where they would have previously listened to Spotify and other creative platforms. Analysing Spotify data relevant to 200 weekly top-charting songs in 60 countries across all continents (except Antarctica), Sim et al. found that consumption rates declined an average 12.5% during lockdowns. On the other hand, Sim et al. found the consumption of video-based music on YouTube increased significantly when confirmed Covid-19 cases were high, suggesting that when not at work or engaged in complementary activities such as walking, house cleaning, or shopping, there was a preference for both aural and visual stimuli rather than aural alone.

The early years of the pandemic saw the following phenomena in relation to patterns of user engagement, subscription, and activity:

Online Platforms

- 66.7% growth to 50 million YouTube subscribers from October 2020 to September 2021, and 60% growth to 80 million subscribers from September 2021 to November 2022 (Variety, 2022);
- 29.9% increase in online music service subscribers globally from 2019 to 2020 (IFPI, 2022);
- 19.6% increase in active users of Spotify streaming services in the US from 2019 to 2020 (eMarketer, 2021);
- An increase of 18.1% active worldwide users of online video games from 2019 to 2020 (Statista, 2022);
- 31.6% increase in downloads of the Vimeo mobile app from 2019 to 2020, its biggest increase across the period 2015 to 2022 (AppMagic, 2023);

- 73% increase in TikTok iOS and Apple users from January to November 2020 (Airnow, 2022);
- 78.8% increase in the total number of hours watched on YouTube Gaming Live across the 2020 year (Streamlabs, 2022b);
- a surge of 194% in online-only art auctions (Christie's, Sotheby's, and Phillips) in the 2020 year (Statista, 2023);
- a major spike in concurrent users on the Twitch gaming platform, from an average of 1.44 million in the first quarter of 2020, to 2.34 million in the second quarter of 2020 (a 77.1% increase) (Streamlabs, 2022a); and
- 21.4% increase in 2020 in the average amount of time spent reading in the US (Bureau of Labor Statistics, 2022a).

Sales, Purchases, and Subscriptions

- 93.8% increase in global sales in the online art and antiques market from 2019 to 2020 (Art Basel, 2023);
- 15.5% increase in paid subscribers to Netflix in the first half of 2020 (Netflix, 2023);
- 33.9% increase in net profit for the LEGO group from 2020 to 2021 (LEGO, 2023);
- 24.4% increase in global sales of the Mattel Barbie brand from 2020 to 2021 (Mattel, 2023); and
- 23.7% increase from 2019 to 2020 in expenditure on reading material per consumer unit in the US, its biggest spike across the period 2007 to 2021 (Bureau of Labor Statistics, 2022b).

Data in terms of the return to live performance reveals mixed results. A recent report by TRG Arts (Robinson, 2023) shows that recovery in the US, Canada, and the UK across four main performing arts categories – theatre, ballet, classical music, and performing arts centres – saw positive figures for performing arts centres and ballet. In the 2022 calendar year, both areas experienced higher ticket revenue growth compared to 2019, the year before the pandemic hit (22% increase in performing arts, 17% in ballet). On the other hand, revenue and ticket sales in theatre and classical music were still substantially down compared to 2019 (theatre was down 33% in both revenues and ticket sales, classical music was down 3% in revenues and 18% in ticket sales). Although many of the world's museums invested heavily in attracting and retaining audiences in both in-person and virtual ways, the data to date remain somewhat gloomy for many of the great museums, with total numbers of visitors in 2022 in several major institutions still down substantially compared to 2019 (pre-pandemic) figures: the Louvre in France (−20%), Vatican Museums (−26%), Tate Modern in UK (−36%), and the Metropolitan Museum of Art in the US (−34%) (Art Newspaper, 2023).

Creative Industries Innovations for Audience Engagement during Covid-19

As discussed earlier in this chapter, lockdowns led artists and arts organisations to urgently increase their experimentation with creating, managing, and shifting content online. Onderdijk et al. (2021), following the cancellation of the De Gentse Feesten festival in Belgium, describe how they created three live-streamed music performances focused on social connectedness, with each having a specific strategy employed to be both experimented with and evaluated. The first concert enabled half of the participants to vote on the final song to be performed by the artist, thereby promoting audience agency. In the second they divided the audience into three groups: "a group watching a normal livestream, another watching a livestream with YouTube's 360° option, and a group watching with a virtual reality (VR) headset" (Onderdijk et al., 2021, p. 3). In the third concert, the focus was on social connectedness, with half the group watching a normal livestream, and the other watching via Zoom and with the chat function enabled.

Onderdijk et al. (2021) recruited 128 participants of a range of ages and from 15 different countries, most of whom were from Europe, with seven of the 128 from other nations (e.g., India, Argentina, the UK, and the US). After implementing a rigorous set of testing and evaluation procedures, the researchers determined that:

1 Those with the option to vote for the final song did not experience greater feelings of agency.
2 Those with VR headsets felt a stronger sense of presence than those watching a regular live-stream.
3 Those participating in the live-stream via Zoom with chat enabled experienced a stronger social presence than those in the regular live-streaming method.

The authors recommend that promoters, event organisers and performers should focus on promoting audiences' feelings of presence, with Zoom (social presence) and VR (physical presence) proving to be valuable strategies in this social experiment. The authors also argue that the findings suggest that future music performances might be offered in a live setting (with or without the need for social distancing) as well as being live-streamed (paid or unpaid), and that VR and Zoom are options for audiences to increase their sense of engagement and presence during the experience.

Hadavi et al. (2022) report on the implementation of a virtual art and music exhibit, where eight musical pieces were selected and 28 visual artists from around the world invited to visualise two new artefacts in

response to two of the eight musical pieces, resulting in 56 artworks displayed in eight virtual (3D) rooms. Using the pre- and post-experiment positive and negative affect schedule tool (PANAS), and involving 160 participants from North America, Europe, Oceania, and other locations in the pre-test, and with 58 completions of the post-test survey, the authors found that, in general, arts engagement increased participants' positive mood and decreased their negative mood. The study points to the ways in which the arts can have a positive effect on mental health and wellbeing – two areas significantly challenged by the pandemic. The authors also argue that there is potential for live or in-person gallery experiences to include musical works aligned to specific visual pieces, to further enhance the benefits for viewers, and in particular to support their mental health and wellbeing.

In Italy in 2020, the Uffizi gallery opted to involve two social media influencers in their online activities, which saw significant growth in audiences under the age of 25 including a significant number based overseas (Giusti, 2023). The gallery embraced key social media platforms including TikTok, Instagram, Facebook, and others and increased their subscription and audience base across all these social media platforms. The gallery also embarked on a "scattered Uffizi" approach, where smaller localised spaces were activated and works that were originally created in the relevant region returned to these spaces for the public to engage with and learn from. This strategy also saw an increase in the number of overall visitors to the gallery and its satellites. The strategies implemented by the Uffizi gallery in both digital spaces and through its satellite program reveal that audiences were ready to engage with art both during lockdowns (digital) and when able to resume travelling to in-person experiences.

Howard et al. (2021), via interviews with 77 young musicians (from the popular music genre) in England, Australia, and Portugal, found that although they experienced loss of jobs and income, there was positivity about using the additional time in lockdowns to both produce and consume music. Many of these young musicians moved their existing and new material online, and further established their social media presence, enabling audiences to stay engaged with their music so that when lockdowns were lifted and live performances re-activated, audiences had maintained their connection to and interest in the musicians' work. This strategy of establishing or further acti-vating an online presence during the pandemic proved to be an effective way for many in creative industries to stay connected to their audiences as well as grow their patrons in some cases. It was not necessarily easy, however, with artists required to rapidly develop digital literacies and strategies to maintain social and audience con-nections (Skaggs, 2023).

There are numerous calls from researchers and thinkers to place great emphasis on the future for engaging audiences in creative industries fields, both in terms of innovations that producers have had success with, as well as how audiences have responded to these new forms. Reports continue to emerge in relation to the innovative strategies that large arts organisations have developed – these strategies enabling audiences to feel part of the arts experience and journey either directly or indirectly (Brilli et al., 2022; Sargent, 2021). Audiences are now increasingly interested in and attuned to a participatory arts culture, with divisions between audience and artist increasingly blurred. In fact, it is argued that audiences "expect to be able to insert themselves into the story of an artwork, and to have access to multiple lines of communication – with performers as well as other audience members and participants" (Sargent, 2021, p. 70). This was often supported through the chat function in various social media platforms such as the social audio platform Clubhouse, where an audience member could ask a question of the solo artist or band, or connect with other audience members (Carr, 2022), creating feelings of connectedness and shared experience (Swarbrick et al., 2021).

The calls for ongoing reflection, research, and action by key leaders and creatives in the sector are omnipresent, in particularly in terms of the producer–audience relationship and interactions. Reason et al. (2022) argue that in terms of the way forward and audiences in particular, "our collective response to what comes after Covid-19 cannot be passive. There is a need instead to actively build back differently and in a conscious and engaged manner" (p. 539). The authors also refer to what will be a raft of new research in years to come:

> There will be publications on the impact of Covid-19 on digital performance and our understanding of liveness; on risk, accessibility and diversity; on the legacy in terms of infrastructure and skills; on audience experiences of socially distanced performances, balcony performances, zoom performances, outdoor performance, audio renditions of formerly visual performances, etc. There will be assessments of what has changed, and why nothing has changed. There will be scholarly cohesion, scholarly argument, scholarly stand-offs. (Reason et al., 2022, p. 543)

It is clear that a collective approach to designing, testing, assessing, and refining methods for audience engagement is necessary towards a post-pandemic future for creative industries. Governments need to work closely with the creative industries sector around the design and

implementation of policy – with a particular emphasis on the rapidly expanding digital creative industries experiences – given the significant resourcing and expertise required for viable and ongoing shifts into this area, and to ensure that populations are not experiencing digital poverty (Carr, 2022).

Large arts institutions should arguably take on board the moral responsibility for sharing their knowledge and insights with the sector, with smaller and less-resourced arts organisations, and with individual artists, in order that these key stakeholders are not left behind due to equity and resourcing issues. Researchers in the academy will need to play a critical role in working with government and creative industries stakeholders to construct strong research agendas to track the sector's developments in the new digital creative industries, and in terms of in-house, public, online, and participatory cultures. Finally, audiences should be seen as key constituents for the sector to consult with, to engage in co-creation projects, and as contributors to research, to enable them to see their part of the creative industries as an absolutely integral one moving forward and to maintain new audience relationships and experiences that emerged during the early years of the pandemic.

Conclusion

There is a great deal of research needed in terms of the ongoing ways in which audiences engage with arts and culture – across in-venue live performances and experiences, at both ad-hoc and planned public events, and in terms of at-home experiences. The systems driving creative industries have been disrupted and audiences and creators are working through what will eventually become more permanent changes. The extent to which the concept of at-home arts and cultural experiences becomes a more entrenched part of psychosocial settings is a critical issue for creative industries moving forward, and raises several important questions:

- Will some segments of arts audiences continue to prefer at-home experiences, due to their lower cost, increased health protocols and safety, and relative ease of access?
- Do producers of creative content have the resources to continue to develop and maintain high-quality, at-home experiences and retain or grow this audience segment?
- Will audiences accept a cost-beneficial user-pay system for certain online content such as streamed events?
- Will creatives be adequately compensated for their work if organisations do adopt online user-pay offerings that may be economically very successful?

- In what ways can marginalised communities with limited access to digital infrastructure have greater access to low- or nil-cost experiences in the home or in community spaces?
- How might audiences develop digital literacies that enable them to fully engage with creative industries content?
- Will parents and their children engage more regularly with the arts now that the possibilities to do so in the home have been enhanced considerably?

Regardless of what the future for online experiences might involve, many creative industries sector participants have invested heavily in the shift to digital technologies and platforms, so it is important that this momentum continue given that audiences are now accustomed to a wide range of at-home digital practices and experiences, in addition to those in live settings.

Digital policies, infrastructures, and simple and equitable access methods are certainly needed for the future creative industries landscape. In addition, ongoing research and analysis is critical, both at a policy level and in terms of government investment, given the access to digital platforms is not uniform across societies and revenue models remain poorly understood as well as problematic in terms of their cost-benefit ratio. The shift of content to online platforms also involves additional factors that need to be addressed, including copyright and royalty schemes, both of which are areas that have been amplified and challenged with this latest crisis.

Ultimately, the future will require that creative industries institutions and individual artists find a balance between in-person, hybrid, and online formats and experiences, exploring how various forms of engagement can work independently and together to create a richer and more equitable experience for consumers of creative content. There is great opportunity for both producers and audiences moving forward, with the likely future scenario summed up in the following view:

> The creativity of artists around the world combined with the inquisitiveness of their audiences will dictate that, alongside the return of live culture, the fast evolving worlds of online, digital, virtual and hybrid culture are here to stay. (Sargent, 2021, p. 76)

Although challenges remain, the highly motivated and creative minds of those working in the sector, and their proactive and engaged audiences, will continue to lead the sector forward into new and exciting territory.

References

Airnow. (2022, February 14). Number of TikTok monthly active users (MAU) via iOS worldwide from January 2019 to January 2022 (in millions) [graph]. *Statista.* https://www.statista.com/statistics/1090767/tiktok-mau-worldwide-ios

AppMagic. (2023, January 11). Number of Vimeo mobile app downloads worldwide and in the United States from 2015 to 2022 (in millions) [graph]. *Statista.* https://www.statista.com/statistics/1251969/vimeo-app-downloads-us-and-global

Art Basel & UBS. (2023, April 4). Total online sales of the art and antiques market worldwide from 2013 to 2022 (in billion U.S. dollars) [graph]. *Statista.* https://www.statista.com/statistics/886776/online-art-and-antiques-market-total-global-sales

Art Newspaper. (2023). World's top art museums still reeling from pandemic shock [graph]. *Statista.* https://www.statista.com/chart/30018/most-attended-art-museums

Barnett, T. (2022). Covid-19. In M. Reason, L. Conner, K. Johanson, & B. Walmsley (Eds.), *Routledge companion to audiences and the performing arts* (pp. 418–423). Routledge. 10.4324/9781003033226

Basu, P. (2023). Performance, cultural resistance and social justice: India's creative economies since the Covid-19 pandemic. *Cultural Trends*, 1–15. 10.1080/09548963.2023.2212627

Bradbury, A., Warran, K., Mak, H., & Fancourt, D. (2021). *The role of the arts during the Covid-19 pandemic.* University College London. https://discovery.ucl.ac.uk/id/eprint/10159116/1/Arts%20during%20covid-19%20ACE%20report.pdf

Brilli, S., Gemini, L., & Giuliani, F. (2022). Theatre without theatres: Investigating access barriers to mediatized theatre and digital liveness during the Covid-19 pandemic. *Poetics*, 101750. 10.1016/j.poetic.2022.101750

Bureau of Labor Statistics. (2022a, June 23). Average daily time spent reading per capita in the United States from 2014 to 2021 (in hours) [graph]. *Statista.* https://www.statista.com/statistics/622525/time-reading-us

Bureau of Labor Statistics. (2022b, September 8). Mean annual expenditure on reading per consumer unit in the United States from 2007 to 2021 (in U.S. dollars) [graph]. *Statista.* https://www.statista.com/statistics/326839/us-household-spending-on-reading

Cabedo-Mas, A., Arriaga-Sanz, C., & Moliner-Miravet, L. (2021). Uses and perceptions of music in times of Covid-19: A Spanish population survey. *Frontiers in Psychology*, *11*, 606180. 10.3389/fpsyg.2020.606180

Carr, P. (2022). Introduction: Covid recovery and early Covid music literature. *Journal of World Popular Music*, *9*(1–2), 5–30. 10.1558/jwpm.23347

Damodaran, A. (2022, June 23). *Arts in times of pandemics and beyond* (online edn). Oxford Academic. 10.1093/oso/9780192856449.003.0008

De Peuter, G., Oakley, K., & Trusolino, M. (2023). The pandemic politics of cultural work: Collective responses to the Covid-19 crisis. *International Journal of Cultural Policy*, *29*(3), 377–392. 10.1080/10286632.2022.2064459

Drake, J., Papazian, K., & Grossman, E. (2022). Gravitating toward the arts during the Covid-19 pandemic. *Psychology of Aesthetics, Creativity, and the Arts.* 10.1037/aca0000471

eMarketer. (2021, October 12). Number of active users of major music streaming services in the United States from 2016 to 2025 (in millions) [graph]. *Statista*. https://www.statista.com/statistics/293749/spotify-pandora-number-active-users

Giannini, T., & Bowen, J. (2022). Museums and digital culture: From reality to digitality in the age of Covid-19. *Heritage, 5*(1), 192–214. 10.3390/heritage 5010011

Giusti, S. (2023). Museums after the pandemic, from resilience to innovation: The case of the Uffizi. *International Journal of Cultural Policy*, 1–14. 10.1080/10286632.2023.2167986

Hadavi, S., Kennedy, K., Mariotti, G., & DeSouza, J. (2022). VisualEars: How an immersive art exhibit impacts mood during the Covid-19 pandemic. *Frontiers in Psychology, 13*. 10.3389/fpsyg.2022.910767

Howard, F., Bennett, A., Green, B., Guerra, P., Sousa, S., & Sofija, E. (2021). 'It's turned me from a professional to a "bedroom DJ" once again': Covid-19 and new forms of inequality for young music-makers. *Young, 29*(4), 417–432. 10.1177/1103308821998542

IFPI. (2022, March 22). Number of paying online music service subscribers worldwide from 2010 to 2021 (in millions) [graph]. *Statista*. https://www.statista.com/statistics/292475/number-paying-online-music-service-subscribers-worldwide

LEGO. (2023, March 7). Net profit of the LEGO group worldwide from 2009 to 2022 (in billion Danish Kroner) [graph]. *Statista*. https://www.statista.com/statistics/292305/lego-group-net-profit

Mak, H., Fluharty, M., & Fancourt, D. (2021). Predictors and impact of arts engagement during the Covid-19 pandemic: Analyses of data from 19,384 adults in the Covid-19 social study. *Frontiers in Psychology, 12*. 10.3389/fpsyg.2 021.626263

Mattel. (2023, February 22). Gross sales of Mattel's Barbie brand worldwide from 2012 to 2022 (in million U.S. dollars) [graph]. *Statista*. https://www.statista.com/statistics/370361/gross-sales-of-mattel-s-barbie-brand

Netflix. (2023, April 18). Number of Netflix paid subscribers worldwide from 1st quarter 2013 to 1st quarter 2023 (in millions) [graph]. *Statista*. https://www.statista.com/statistics/250934/quarterly-number-of-netflix-streaming-subscribers-worldwide

Onderdijk, K., Swarbrick, D., Van Kerrebroeck, B., Mantei, M., Vuoskoski, J., Maes, P., & Leman, M. (2021). Livestream experiments: The role of Covid-19, agency, presence, and social context in facilitating social connectedness. *Frontiers in Psychology, 12*(21), 1741. 10.3389/fpsyg.2021.647929

Piccio, B., Helgason, I., Elsden, C., & Terras, M. (2022). A hefty dose of lemons: The importance of rituals for audiences and performers at the online Edinburgh festival fringe 2020. *International Journal of Performance Arts and Digital Media, 18*(1), 154–175. 10.1080/14794713.2022.2036489

Reason, M., Conner, L., Johanson, K., & Walmsley, B. (2022). Afterword: Covid-19, audiences and the future of the performing arts. In M. Reason, L. Conner, K. Johanson, & B. Walmsley (Eds.), *Routledge companion to audiences and the performing arts* (pp. 535–543). Routledge. 10.4324/9781003 033226

Robinson, J. (2023, May 5). Not all recoveries are created equal: A snapshot of the four genres. *TRG Arts.* https://trgarts.com/blog/not-all-recoveries-are-created-equal.html

Sargent, A. (2021, April). *Covid-19 and the global cultural and creative sector: Two years of constant learning – New foundations for a new world.* Centre for Cultural Value. https://www.culturehive.co.uk/CVIresources/covid-19-global-cultural-creative-sector-two-years-constant-learning

Schumpeter, J. (2010). *Capitalism, socialism and democracy.* Routledge.

Selen, E., Sunam, A., Akın, A., Biçakcı, H., & Kaplan, A. (2023). The impacts of processes of digitalization on the reception of contemporary art in Turkey during Covid-19. *Cultural Trends, 32*(1), 70–87. 10.1080/09548963.2022.2035191

Sim, J., Cho, D., Hwang, Y., & Telang, R. (2022). Frontiers: Virus shook the streaming star: Estimating the Covid-19 impact on music consumption. *Marketing Science, 41*(1), 19–32. 10.2139/ssrn.3649085

Skaggs, R. (2023). Socially distanced artistic careers: Professional social interactions in early, established, and late career stages during Covid-19. *Poetics,* 101769. 10.1016/j.poetic.2023.101769

Skaggs, R., Hoppe, E.J., & Burke, M.J. (2023). Out of office: The broader implications of changing spaces and places in arts-based work during the Covid-19 pandemic. In I. Woodward, J. Haynes, P. Berkers, A. Dillane, & K. Golemo (Eds.), *Remaking culture and music spaces* (pp. 88–101). Routledge. 10.4324/9781003254805

Statista. (2022, June 29). Users of digital media users worldwide from 2017 to 2026, by segment (in million) [graph]. *Statista.* https://www.statista.com/forecasts/456497/digital-media-users-in-the-world-forecast

Statista. (2023, April 18). Combined number of online-only auctions organized by Christie's, Sotheby's, and Phillips worldwide from 2018 to 2022 [graph]. *Statista.* https://www.statista.com/statistics/1274184/number-online-only-auctions-worldwide

Streamlabs. (2022a, November 7). Average number of concurrent viewers on Twitch from 2nd quarter 2018 to 3rd quarter 2022 (in millions) [graph]. *Statista.* https://www.statista.com/statistics/761122/average-number-viewers-on-youtube-gaming-live-and-twitch

Streamlabs. (2022b, November, 7). Number of hours watched on YouTube gaming live worldwide from 2nd quarter 2018 to 3rd quarter 2022 (in millions) [graph]. *Statista.* https://www.statista.com/statistics/992392/active-streamers-youtube-gaming

Swarbrick, D., Seibt, B., Grinspun, N., & Vuoskoski, J. (2021). Corona concerts: The effect of virtual concert characteristics on social connection and Kama Muta. *Frontiers in Psychology, 12*, 648448. 10.3389/fpsyg.2021.648448

Variety. (2022, November 9). Number of paying YouTube music and YouTube premium subscribers worldwide from 2020 to 2022 (in millions) [graph]. *Statista.* https://www.statista.com/statistics/1344265/youtube-paying-subscribers

Vincent, C. (2022). The impacts of digital initiatives on musicians during Covid-19: Examining the Melbourne digital concert hall. *Cultural Trends,* 1–17. 10.1080/09548963.2022.2081488

Walmsley, B., Gilmore, A., O'Brien, D., & Torreggiani, A. (2022). Culture in crisis: Impacts of Covid-19 on the UK cultural sector and where we go from here. *Centre for Cultural Value.* https://www.culturehive.co.uk/CVIresources/culture-in-crisis-impacts-of-covid-19

White, J. (2023). *Innovation in the arts: Concepts, theories, and practices.* Taylor & Francis. 10.4324/9781003142393

Yue, A. (2022). Conjunctions of resilience and the Covid-19 crisis of the creative cultural industries. *International Journal of Cultural Studies, 25*(3–4), 349–368. 10.1177/13678779221091293

3 Artists' and Creatives' Motivation and Innovation during the Pandemic

As discussed in Chapter 2, audiences were essentially forced to shift their patterns of engagement with creativity to online spaces and platforms during the first year of the pandemic, given venues were either entirely shut down, or remained partially open with numerous health protocols and restrictions. For those venues that shut down entirely, there was a gradual reopening and return to operations, with some continuing to follow health protocols and restrictions. Even when in-person experiences started to return, some audience members felt uneasy about the health risks associated with live attendance so preferred to access creative content online.

Artists therefore immediately shifted their attention to finding ways to not only stay connected to audiences, to present work online, and to build new audiences, but also to collaborate with their peers in virtual settings, using programs such as Zoom, Facebook, Houseparty, and Instagram. They organised online writing circles, book club meetings, fundraising campaigns, and submissions to government. They also initiated protest movements, recorded music in both synchronous and asynchronous forms, shared their artwork in critique sessions, and discussed creative ideas and new ways of working towards a post-pandemic world. There was not only a theme of resistance to strict health regulations in the early stages of the pandemic, achieved through flash mob performances in several European centres (Gammaitoni, 2022), but also a focus on the need for innovation in response to the shackles placed on the sector by the pandemic. This imperative continues:

> Given the impact of the Covid-19 pandemic on art worlds and related industries around the world, the changing demographics in global arts attendance, the new cultural preferences of younger arts audiences, and the economic challenges that most not-for-profit arts organisations are facing today, we need innovation in the arts more than ever. (White, 2023, p. 81)

DOI: 10.4324/9781003434603-4

Creative industries, which operate via a complex and regularly changing systems model of creation, production, dissemination, and consumption (Csikszentmihalyi & Wolfe, 2014), were faced with an urgent imperative to rethink and adjust their structures and processes which were severely disrupted. Chaos theory (Saitis, 2017) provides a valuable theoretical basis and framework by which to understand the systems inherent to creative industries. Although from the outside creative industries appear chaotic, sporadic, ephemeral, and at times messy, with instability and crises common to the sector, there is well-established order behind this chaos, where stakeholders, institutions and artists establish, manage and navigate complex systems in order to bring arts and culture to societies, and to sustain and preserve this culture. With its metaphor of the butterfly and the butterfly effect, chaos theory is built around the notion that one tiny flap of the metaphorical butterfly's wings can have major consequences for the wider field. Covid-19 began as a small flap of the butterfly's wings, but this soon led to massive global implications and devastation, with sweeping changes and transformations continuing to occur across all parts of economies and societies, with creative industries deeply affected.

The performing arts faced significant challenges when live and in-person performances were cancelled. In the theatre field, shifts to the digital space were not new, with Chatzichristodoulou et al. (2022) and Decrop and Dumont (2023) describing how innovations in digital theatre had been occurring since the turn of the 21st century. What the pandemic did, however, in the case of the performing arts and theatre specifically, was accelerate the pace of innovation and use of digital methods and platforms, in the areas of interactive systems, audience participatory experiences, immersive technologies, augmented and virtual reality, and special effects (Decrop & Dumont, 2023). Zoom technologies were used in a number of cases where rapid shifts were required from in-person to online-only events, with numerous case studies of how Zoom technologies were used in specific productions and situations found in the *International Journal of Performance Arts and Digital Media*. A general view is that three main modes for the digital presentation of theatre became common once the pandemic took hold:

- Pre-recorded content being streamed, either through bespoke platforms or existing streaming services;
- Live intra-media performances making use of new popular technology like Zoom and occasionally including interactive elements;
- Live-streaming entirely new content, either free to view or to paying audiences. (Chatzichristodoulou et al., 2022, p. 2)

Along with the shift of vast volumes of material to the online space, the pandemic has accelerated cutting-edge innovations in such areas as hologram technologies, sensory experiences and wearable devices (Rieple et al., 2023). For example, Apple recently announced the 2024 release of its first augmented reality headset Vision Pro, and Emerge – a small company in comparison – released virtual reality hardware that uses ultrasound to convey the sense of touch. While alternative reality wearable devices are not a new innovation since 2020, the pandemic and the stay-at-home cultures accelerated moves into this area by numerous companies, and there are now a number of alternative reality wearable technologies available to consumers. It also seems likely that there will be a flood of new devices in the coming years as the almost-frenetic pace of innovation in this area continues.

While developed countries will continue to see mediatised innovations such as interactive, immersive, and inclusive hard and soft technologies, the pandemic has also led to workforce disruptions and innovations in developing countries, such as the revised interpretation of *hustling* (Langevang et al., 2022). Hustling, adopted from a positivist perspective, essentially involves strategising and enacting activities focused on survival during periods of intense precarity. More specifically, Langevang et al. (2022) identify hustling practices for creative industries practitioners as "the lived and situated dynamics of improvisation, resourcefulness, savvy, hopefulness, and caring that characterise creative work under conditions of deep precarity" (p. 150). Involving interviews with 12 creative industries workers in the film and theatre industries in Ghana (with significant overlap between the two fields), Langevang et al. (2022) found that there were three interrelated and overlapping practices of hustling exacerbated by the pandemic, namely digitalisation, diversification, and social engagement.

The Music Industry, the Butterfly Effect, and Chaos

Although every subsystem and field of creative industries practice was affected when the pandemic outbreak hit, it was the music sector and musicians who were arguably the most impacted (Gnezdova et al., 2022). The music sector suffered massive shocks as a result of the shutdown of live performance, which was the primary income source for most musicians, and as a result audiences flocked towards pre-existing online streaming platforms such as Spotify, Apple Music, and YouTube, as well as live events that were streamed or pre-recorded and accessed either for free or via pay-per-view. The financial losses for musicians were enormous, exacerbated by the punitively low streaming royalties offered by the major platforms. Even when live performance started to return, it was typically the case that enforced social distancing protocols and

venue capacity limits often meant small box office returns and even losses. In a similar manner to the key influences in the theatre field (discussed previously), Oliver and Lalchev (2022) identified five trends relevant to musicians and audiences that have been accelerated by Covid-19:

- The **evolution of creators,** meaning that the line between creator and audience is increasingly blurred, with innovations such as Apple's sound packs enabling creators to work more closely, albeit indirectly, with major artists' style and content (e.g., Dua Lipa and Lady Gaga).
- The **growth in social audio platforms,** such as the interactive application Clubhouse, supporting creators and fans to converse and engage in various ways, such as providing feedback to musicians and having a say in what is presented in virtual performances.
- The expansion of music content in the **metaverse**, the latter involving "collective gaming, social media, virtual reality and augmented reality" (Oliver & Lalchev, 2022, p. 63).
- The growth in **blockchain and NFT** models, which although complex and problematic territory and systems, can offer income streams to musicians via digital royalties.
- The **ongoing evolution of streaming**, resulting in a rapidly expanding market and opportunity for both music creators and audiences.

Digital initiatives occurred across more traditional music fields as well. Orchestras around the world shifted pre-scheduled performances to live-streamed events, such as the Berlin Philharmonic and Amsterdam's Concertgebouw, with the latter live-streaming a Mahler festival that resulted in 1,856,652 global online attendances, equating to two and a half years of sold-out live concert performances and a hundred times more attendances than a live festival would have been able to achieve (Sargent, 2021). In Australia, the Melbourne Digital Concert Hall was established by two arts manager-musicians; it was originally designed to be a short-term initiative during lockdowns, but it has continued given its relative success. The model was built around giving 80% of pay-per-view income to the musicians directly, and in its first nine months, "the platform presented 233 live-streamed recitals and generated more than AUD\$1,000,000 in revenue for participating musicians and technicians" (Vincent, 2022, p. 6). While the musicians involved found the loss of direct audience relationships to be very challenging, the initiative did provide desperately needed remuneration for those who had lost numerous income sources as a result of lockdowns, and who were in many cases ineligible for government rescue packages. It has now grown to become the Australian Digital Concert Hall and incorporates primarily music but also ballet performance.

Like all creative industries subsectors, the music industry continues its rebuilding phase, with live performance returning alongside significant continuing uptake of streaming services and digital experiences. The pandemic has both disrupted the industry and accelerated innovation, however, there is still considerable lost ground to be made up and work to be done; many live venues have been lost to the industry and royalty schemes remain detrimental to all but the most high-profile artists, and there are ongoing fragilities associated with fragmented industry leadership, dated policy settings, and limited government support in many countries. Innovations in the sector also appear to be outpacing policy settings and government support structures in several Western nations.

Interviews with Current Artists and Creatives: Reflections, Innovations, and Motivations

A substantial body of new data were obtained specifically for this text via an interview phase (with appropriate ethics approval in place) which took place from early December 2022 through March 2023. A total of 35 creative industries participants took part from various locations, with the majority of interviews being conducted live and recorded. Five participants chose to write their responses to the interview questions, feeling that they could contribute more substantially this way. The areas explored included participants' experience and areas of practice in the sector, after which questions focused on both the early and ongoing impacts of the pandemic for them as individuals and as relevant to the broader creative industries. Questions also explored such areas as technologies and online arts practices, the role of social media, and future-gazing as to where the creative industries might be in the next five to ten years.

The artists were from a range of countries and disciplines of practice, across the span of ages, experience levels, and gender. Artistic disciplines included music, theatre, visual arts, digital art, design, photography, education, art and technology, multimedia arts, and arts management. The majority were Australian (22), with the remaining participants from the UK (3), US (3), Singapore (2), Norway (1) and several who split their time between two countries, either physically (pre-pandemic) or virtually (since 2020), including Australia/US (1), Australia/Ukraine (1), Australia/China (1), and Macedonia/US (1). Interviewees were recruited via contacts made to arts organisations worldwide, the author's network, and the snowball technique. Participants agreed to take part on the condition of strict anonymity, given the sensitivities of the time, and the often very significant personal and professional impacts caused by the pandemic. Although there were many more inquiries in response to the call for interviewees, and many questions from key stakeholders

in the sector about the interview protocols, some opted out of partici-
pating due to time zone challenges, survey fatigue, or a preference not
to relive traumatic experiences. There was a clear sense that for some
creative industries participants, it was a matter of moving on and not
reliving or returning to the creative destruction caused by the pandemic.

As is typical of creative industries work patterns, most interviewees
worked across several forms of practice, such as teaching, exhibiting,
publishing or performing, writing for a range of media outlets or orga-
nisations, arts administration, and non-arts work. Several worked across
more than one art form, such as a performing artist who was active in
contemporary theatre (performing and script writing) and popular music
performance, and who also engaged in commercial graphic design work.
The majority of interviewees self-managed a portfolio-type career, with
multiple job holdings and a range of work types (freelance, part-time,
contract, project-based, and full-time) and although mostly online
during the first year of the pandemic, were now experimenting with
hybrid styles of working.

The interviews were energising, confronting, and even disturbing at
times, in terms of the ways in which artists and creatives were affected by
and responded to lockdowns and the ongoing uncertainties and changes
in the creative industries landscape. Many of the themes found in the
literature were present, including the tremendous losses in work
opportunities and income, the loss of in-person experiences (e.g., gallery
events, live performance, art conventions, collaborations, and
rehearsing), the shutdown of studio working space(s), pressures associ-
ated with maintaining audiences and clients, and references to personal
trauma and high levels of anxiety as a result of lockdowns and fear-
mongering media campaigns.

There were mixed reports in relation to accessing government rescue
packages or new grant and support schemes that were established in the
first year of the pandemic, with some interviewees becoming beneficiaries
of these schemes, while others were deemed ineligible. Many participants
revealed how they drew on their financial reserves, the goodwill of
others, and their personal determination, resilience, and fortitude. There
were also a surprising number of references to the considerable positive
outcomes for many participants, who managed to find a silver lining
amidst the darkness, with several reflecting on the green shoots to
emerge from the ashes left behind.

Negative Impacts of Covid-19

The performing arts, regardless of each person's discipline of practice,
were frequently cited as being the most severely affected area, given the
core methods of working and presenting in these disciplines relied on in-

person rehearsals, live performance, and audience interaction in both outdoor settings and indoor venues. References were made by some to the likelihood of smaller venues for the performing arts being shut down permanently, without significant new government or philanthropic investment to bring them back to operation. Some also referred to how members of their audience base have found it difficult to return and readjust to in-person experiences and to engaging in dialogue in live settings, given the loss of in-person communication during lockdowns, as well as ongoing fears about the health risks when attending in-person performances.

Personal narratives provided a stark reminder of some of the lived realities for people during the first year of the pandemic in particular. Some individuals referred to major personal struggles and even having claustrophobia-style panic attacks. A visual artist, who was strongly encouraged to isolate due to their disability and already-weakened health condition, described the situation as an "apocalyptic nightmare … I didn't really want to fracture and go mad. A lot of people did. They seem[ed] to have lost the plot". A musician described the impact as "soul destroying, and I would say that it has changed me permanently in negative ways that I have to really work hard daily to overcome those impacts … emotionally and psychologically". This same musician went on to describe the personal frustrations and realisation surrounding parts of the early Covid-19 discourse and narrative, with the following compelling metaphor:

> When it all started and everyone did that whole "we're all in the same boat" narrative. And at first I bought into that because, you know, everyone was stuck at home and everyone had their kids home and, and it took me probably longer than it should have to realise that actually wasn't true, and it's that we're all in the same storm, but we were certainly not all in the same boat … some of those big boats that people were in that were relatively comfortable and luxurious, they reached the destination on the other side of the storm, while those of us in the little row boats or even canoes were still out there paddling real hard. (Musician)

There were several other participants who referenced significant negative impacts of the pandemic on business activity and income. A couple who ran a thriving music teaching business described how the company lost "hundreds of thousands of dollars" in the first year of the

pandemic; they in turn chose to scale the business back significantly with Zoom proving somewhat adequate for teaching the much smaller numbers of students who chose to continue their learning. Similarly, a photographer talked about the significant number of photographic businesses that shut down as a consequence of lockdowns and the industry-wide loss of work (particularly in wedding photography) – in their case losing tens of thousands of dollars of previously booked work in the first year of the pandemic alone.

This photographer also described how the very substantial inflation-driven and pandemic-influenced cost increases associated with printing and framing photographic work added another layer of financial stress, a view echoed by a painter based who reflected on the major challenges associated with high inflation and increased costs to produce and exhibit work in north America. A digital artist referred to the challenges associated with trying to establish a mock studio in a very small apartment in a congested city, all the while caring for a young child who was unable to attend childcare or even go outside. A visual artist who also performed in a rock band provided a philosophical take on the initial and ongoing impact of the pandemic when referring to the lived reality that "society seems to be changing in a way where by the time you adapt to one version of it, you're left behind".

The raw emotion for some was palpable at times, with pressures to find ways to replace in-person practices (e.g., rehearsing, performing, and collaborating) with digital or virtual experiences nothing short of urgent, intense, and often problematic or ultimately impossible. Added to this were the stresses of replacing lost income streams, the struggles associated with maintaining existing employment using stay-at-home methods, and the loss of in-person collaborations with peers. These various impacts resulted in substantially increased mental health stresses, with many continuing to feel "on edge" as they navigated and set out to determine their place and existence both during lockdowns and also when looking towards the future creative industries landscape. During initial lockdowns, a theatre practitioner described "having some days where I really felt quite depressed and hopeless", an artist-academic commented that "it was all thoroughly exhausting", and an arts administrator who lost their employment commented on the impact of being stood down from their full-time role: "It affected me that I was stood down … I felt like I had lost my identity".

An illustrator described how they had struggled to find a suitable and available co-working space following the lifting of lockdowns, given the industry was still hovering between working from home and returning to in-person spaces, which this person felt meant a loss of human connection, collaboration, and peer support. A musician commented that they remain concerned at how lockdowns splintered the normally highly

collaborative performance scene in their location, which they feel is still yet to return to what it was prior to the pandemic. Another musician talked about the pandemic amplifying the already-negative effects of Brexit, with travel and work opportunities (e.g., performing and teaching) suffering further, and the previous practices of working in various European countries and having visiting performers and experts brought to the UK made even more difficult than it already was.

A very experienced arts administrator, who has worked internationally in theatre companies and for music and visual arts festivals for over 30 years, provided significant insights into the massive challenges the pandemic caused in 2020 – the year that they were planning to run the next iteration of an international music competition. After a stop-start process of attempting to reschedule the event three times, with each attempt abandoned due to recurring lockdowns, international border restrictions, and new mutations of the virus, the organisation made the decision to run the competition online and to stream it to global audiences. It was a brave but necessary move that came with hugely complex implications for their normal systems of operation.

For this CEO, the shift to a fully streamed event contributed to further depletion of the company's financial reserves, with the costs of live-streaming "three to four times" greater than running the event in person and in live venues, with paywall revenues (online ticket sales) extremely low and disappointing. This experience led the organisation to accept that they simply could not afford to run the event in this way again. This CEO also discussed how audiences were returning in droves to pre-event fundraisers and promotional events in 2022 and 2023, despite the potential health risks, with people generally accepting that Covid is here to stay for the time-being, but life needs to return to some sense of normality. As this person described, "gone are the days of people wearing masks. Gone are the days of people worried about the person sitting next to them coughing and spluttering". This cultural leader also commented on the view in many international networks that they were a member of that Covid-19 "only exists if you test".

Positive Impacts of Covid-19

While there were many negative impacts for interviewees, their organisations, representatives, and dedicated audiences, there were also positives in terms of lockdowns or periods of furlough being a time to reset, refresh, and create new work, or to return to creative practice and the craft of making art. Two musicians described how they spent a lot more time practicing their instrument in lockdowns, finding it a positive reconnection to the art of playing. For other participants, lockdowns motivated them to refocus and to question what they were working on,

with, and for, and in some cases resulted in them completely realigning and redesigning work patterns and creative practices. For example, a visual artist stated that the pandemic enabled their network of "creative minds to find more creative methods to reach their audiences".

An interesting case came via the experiences of a theatre practitioner who, after the initial shocks of shutdowns and lockdowns, led the establishment of a writing group focused on the theme of hope, involving new collaborations, script design, and the creation of short video clips such as interviews with the playwright. This was all achieved over Zoom which enabled audiences and followers to see that new work was being developed and plans were in place for productions to resume in future. This set of initiatives gave the theatre practitioners involved a great sense of focus, hope, and desire to make a significant contribution to the sector once live performances resumed. Audiences were also excited at the prospect of seeing new work when in-person events returned to the cultural landscape.

A visual artist, in a very humble way, described how they felt guilty to some extent that they enjoyed significant positives as a result of lockdowns. One was the significantly reduced travel time associated with their teaching at a major institution some five hours' drive each way, resulting in ten more hours a week to be in the studio. In this situation, Zoom enabled students to see the instructor's studio in the background, and to ask questions about the studio setup and modes of practice. This artist also referred to the fact that there were fewer distractions during lockdowns, more online sales of work, and the opportunity to apply for public grant monies to invest in new creative projects and outputs. They were almost apologetic when stating that they had "more time, more money, more opportunities kind of all at once". Citing the loss of social interaction with other artists as a major challenge, this artist was motivated to set up a peer network with colleagues in various global centres to interact and share with one another while in lockdowns. For this person, it was also a time to explore software, such as 3D modelling technologies.

The Benefits of the Shift to Digital and Online Working

Many referred to the new opportunities that the shift to digital practices provided for both audience or customer connection and development, as well as much-needed income through ticketing or sales of artefacts. A designer commented on the additional time that became available as a result of reduced travel both to and from work, as well as less domestic and international travel. This person, CEO of a graphic design firm, experienced significant growth in work requests and consultancies and attributed this, to a large extent, to clients and businesses having more

time and an urgent need to develop new online capabilities and digital brand presence. A musician described how they promoted themselves with additional video content on Instagram to stay connected to audiences while live performance was shut down, and in this case they were able to grow their audience base. Another musician commented that they were able to access live-streamed orchestra performances as part of their personal and professional skills development, which they would never have previously been able to access in-person due to cost and time factors.

There were also other unexpected benefits of the shift to online platforms identified by participants. A photographer referred to significant growth in international audiences for their work, across all continents "except Antarctica". They noted that this promoted engagement and communication across cultures, reflecting that peoples' feelings and emotions are universal, which for this photographer was a great learning and unifying experience. Another photographer based in a major global centre referred to the sudden application and use of Zoom to direct people remotely for photo shoots. This remote direction included styling and makeup, model direction, shot composition, lighting, and location selection. This photographer also revealed the intense work that they and their colleagues undertook to replicate the typical in-person photography studio experience in an online environment, using specialist photographic software programs and involving the significant generosity of specialist creatives in such areas as fashion design, styling, etc. This person talked about the very positive results for both facilitators of remote photo shoots and for the business owners who were able to complete their photographic projects or commissions for clients. They did, however, also comment that it was extremely tough and draining work.

A digital content creator, who was hired by a network of libraries, worked closely with staff to rapidly expand the digital library offerings, and found that as staff warmed to the possibilities and processes there were some excellent resources developed for users to access from any location. This person commented on how it expanded the library's reach, improved accessibility and equity, and amplified the library network's socio-cultural importance. An installation artist also found that lockdowns and the shift to online collaborations and networking resulted in the formation of new partnerships and creative opportunities that may not have been likely before the pandemic; this was very pleasing and encouraging for this artist. Another visual artist described how they were a beneficiary of new arts funding for digital projects during the early part of the pandemic, which suited their work in digital art as well as their augmented and virtual reality projects, and which enabled them to create new international collaborations and income-generating opportunities.

An illustrator described online sales of artwork (his own and others) as going "bonkers" during the first year of the pandemic, despite the shutdown of live art fairs and events such as Comic-Con. This person commented that people (non-artists) in lockdown who retained their employment had unanticipated reserves of cash, given they were not dining out, shopping in store, or undertaking travel; many subsequently turned to redecorating their homes and purchasing artwork as part of this refresh. Another visual artist described how lockdowns brought significant positives in terms of the joys of creative freedom: "finally I can do what I always wanted to do, like just be an introvert and just be in my room drawing". A visual artist in the later stage of their career described how lockdowns occurred at a somewhat fortunate time in that they had the mental space and time to go through and scan hundreds of slide images of their work from decades of practice, and to incorporate selected works into a book that they were finishing.

There were many other positive narratives presented around the shift to digital during the first year of the pandemic. A digital artist described how they were able to focus on new commissions and finish a children's book, while an art technologist used lockdown time to venture more seriously and strategically into VR territory and create new work and collaborations. An illustrator reflected on the fact that lockdowns meant a time of great productivity, or what they described as a "creative boom", and a multimedia artist described how they became much more curious during lockdowns and "started to listen to a lot more audio-books, ... to research and enjoy creative content [given] a lot of information was shared via social media between friends". A photographer described how they were able to work remotely with curators and technical staff in relation to pre-pandemic bookings for gallery exhibitions in New York and Italy, enabling them to have significant control over the placement of images in the spaces, and to benefit from sales of work despite the health protocols and smaller numbers of visitors permitted during limited gallery opening times.

The Zoom Culture

Zoom became a somewhat reluctant lifeline for many, be this in continuing to run music lessons, workshops and rehearsals, meetings with clients, or in collaborating with peers in the sector for urgent support strategies, ideas sharing, and for generating new projects and income-producing methods. Some reflected that the shift to Zoom did certainly lead to benefits. Two musicians each commented that although Zoom was not as effective for teaching lessons as it is in person, the experience of working in this way meant that the sector had started to see the possibilities for creating access and opportunity for students in remote or

regional locations, and who were unable to work in person with experts in major global centres. Following the lifting of lockdowns, these educators both decided to continue to offer Zoom lessons to people if this meant they could continue their studies, finding it suited students and parents if they were feeling unwell, or were hampered by travel restrictions or time pressures.

A documentary filmmaker described how they were able to interview many experts across North America and around the world – something that would have been impossible without the shift to a Zoom culture and acceptance of this method of interacting. This person also commented on the cost savings of not having to fly to numerous global centres to conduct in-person interviews, as well as the benefits to the environment. Visual artists and photographers used the time to catalogue and refine their existing works, with some creating and designing photo books for online or print sales and distribution. For example, one photographer described how they "finally went through [my] work for the past five years and I never [previously] had time to do this". This person also described how the pandemic led to their most successful photographic project to date (both artistically and commercially) largely as a result of the increased time to devote to creative thinking and practice. They referred to the vastly different outside world during lockdowns: "empty streets, empty malls, empty car parks and you could go and explore this almost, I guess, surrealistic kind of post-apocalyptic world as if humans were taken away from it. Which [was] a great creative trigger".

Social Media and the Pandemic

For most interviewees, social media was of increased importance from the outset of the pandemic, allowing them to maintain connections to existing audiences, attract new followers, and connect to other artists and learn from their ways of using social media. Several participants referred to the ways in which social media enabled them to raise their profile or generate interest in their new work and project plans once lockdowns and shutdowns eased. A visual artist referred to one of the benefits being "the analytics that some platforms provide, helping me further to engage more effectively with my audience". While the majority of interviewees recognised the importance and potential value of a strong social media presence, some did lament that they had not invested sufficient time to take full advantage of these platforms.

While there were positives identified, negatives were also cited including the amount of time it takes to manage a social media presence, the saturation of images on social media platforms such as Instagram and Facebook, and challenges to notions of truth, indexicality, and perception caused by the flood of generative artificial intelligence (AI)

outputs. The recent explosion of AI-driven digital art and activity led one photographer to refer to "a massive snowball of randomness". Another photographer referred to the number of major photographic competitions where the winner eventually conceded that they had used AI to generate the image. The use of AI remains a hotly contested area across social media channels, typically when people present work as original photographs, despite them being produced entirely using AI technologies. It also reignited debates in social media channels about the nature of what constitutes a photograph and the ethical issues associated with technology-assisted creative production; these debates remain ongoing.

Artists' Concern for Humanity

The pandemic highlighted the strong concern for humanity that many artists feel and the ways in which they sought to provide escape, healing, and pleasure for their fellow citizens. A photographer told a story about a neighbour who was a technical theatre expert who, leading up to Christmas one year, outfitted his façade and entire house frontage with an impressive array of visuals and messages of hope, using equipment that would have been sitting dormant otherwise. It was a success to the extent that donations were collected to support charities to bring people with access and equity challenges to experience the display, and it has continued each year. A more sombre story was recounted by an illustrator who had started to create work referencing the enormous growth in environmental detritus caused by used PPE equipment such as face masks and plastic gloves, with billions of discarded items finding their way into waterways and oceans around the world. As this artist stated with considerable concern, "plastics and the masks will take centuries to decompose and in that time, they'll be consumed by sea life, which we in turn ourselves will consume".

The humanity that creatives shared with their peers was on display in many countries with the formation of new networking groups, for example, some of which went as far as involving reciprocal purchases of participants' works as a way of supporting peers through the most challenging periods and losses in income. A multimedia artist described a community arts project where a small team of artists built a temporary sculpture-style piece in an area frequented by people experiencing homelessness. The residents quickly moved to help the artists to build the work which utilised recycled materials, and became very protective of it for the duration it was in this public space; for example, when strong winds dislocated parts of the work they would put them back in place, or when people looked to damage the work they found ways to protect it from senseless vandalism. These normally marginalised individuals felt

proud to be associated with the work and it gave them an additional sense of purpose, belonging, and social inclusion.

The Future for Creative Industries

When looking to the future, a range of factors and predictions were presented. These included the foreboding and unknown impending impacts of climate change, the likelihood of disruptions to many supply chains such as in the food sector, ongoing change in both physical and digital infrastructure, economic recessions and an ongoing rise in inflation, and new and potentially challenging patterns of audience engagement. For example, a visual artist talked at length about the global challenges surrounding climate change, and how this is likely to significantly affect the creative industries in future, in terms of the work that is created and in terms of the carbon footprint that the sector does or might leave.

Technology was also cited as likely to cause some of the most significant disruptions and changes in the industry in the next five to ten years, be this in the ways that work was presented, or the devices and systems available for audiences to use to engage with creative content. A multimedia artist felt quite strongly that social media would play an increasingly significant role in how artists learn, with platforms such as TikTok featuring an increasing number of short (30 seconds) instructional videos relevant to creative industries practices, such as tips for using Adobe software programs. While various concerns were raised about the impact of technologies on creative industries and in-person experiences in particular, there were also positive predictions, such as that by a visual artist who had great confidence in the younger generations of artists coming through, feeling at ease that they would help to rebuild the arts and find new and interesting ways of ensuring an appropriate and balanced use of new and next technologies alongside traditional artforms and practices.

Several felt there would be a continuation of increasing blending across artforms, and there were also references from participants to the idea of hope for revolutionary change in terms of policy, funding, and recognition for the arts. There was a general sense of increased movement into quality digital spaces, as well as greater acceptance of digital art forms as legitimate creative outputs. This ongoing growth in digital art practices led an illustrator to comment that although there would likely be fewer hard-copy artefacts, those that were produced in limited volumes or editions would potentially be more appreciated and valued by audiences and collectors. A musician provided a very thought-provoking perspective on the future for creative industries:

> I believe that big organisations will be the slowest to change. I believe that the chamber ensembles and chamber orchestras ... are the ones being the most innovative. My students (Gen Z age group) seem to value the idea of freedom over security with many of them stating that they wish to freelance and have variety in their careers rather than join a symphony orchestra and stay there until retirement. There is a lot of flex in programming ... at the moment with more diversity seen across the board. Multi-disciplinary arts will take hold more deeply and boundaries between music genres will blur. Concerts will be live streamed and potentially shorter, people dipping in and listening to one movement etc. Tradition will be challenged and the gatekeepers to careers will change. Competitions will die out and the focus will be on education. I think the sector will be financially challenged but artistically far more interesting in ten years' time. (Musician)

The revolution already caused by generative AI art was seen by many as very likely to have a massive impact on creative industries moving forward, as creatives and cultural leaders experiment with the possibilities that AI affords. While it was seen as a useful tool by some interviewees, several participants commented on their deep concerns with generative AI art and how it misappropriates artists' works in various platforms, how it falsifies notions of truth and perception, and the "moral panic" that it has caused. A visual artist stated they were disturbed with some technological innovations and "worried about the future of art", but a "glass half-full" view was presented by an installation artist who stated: "I think good art is always going to be impossible to automate", and a designer put forward the view that "I don't think [AI] will take our place. We just need to find out how to play along". Another designer was not overly concerned about the automation of many industries, arguing that creatives will always be needed above machines and AI, given human beings bring imagination and alternative forms of thinking that computers and software platforms simply cannot do as well.

Government and policies were specifically mentioned by some participants, with those who were able to access emergency funding very grateful for the support that this provided during early shutdowns and lockdowns. Several were hoping that new cultural policy and funding directions would have positive impacts for creative industries. There were, however, some concerns raised in relation to government, such as a musician who was quite sceptical about the existing government in power in their home country, arguing the following:

My feeling is that the current ... government have little regard or respect for the arts sector as a whole. It feels quite vulnerable at present and prosperity or even stability in the sector seems unlikely in the coming years. This was certainly exacerbated by the pandemic. (Musician)

Despite concerns about the future for the sector, there were also other positives to emerge in relation to work practices, including more working from home and reduced travel, resulting in the benefits of more creative thinking time as well as benefits for the environment. A designer was very positive about online meetings with clients and colleagues, given the cost and time savings, as well as the increased flexibility to work in the office or at home, and for finding a better work/life balance. A visual artist referred to the pre-pandemic focus on the major arts centres of the world, such as New York and London, but felt that the pandemic would result in a more distributed creative industries sector thanks to the accelerated move to online spaces, networks, sales opportunities, and audiences. Finally, although digital practices were unanimously agreed as a major part of creative industries futures, there were also some who referred to a greater respect for the craft of producing tangible creative artefacts, particularly using analogue techniques in such areas as painting, sculpture, photography, and music.

Conclusion

While there were serious global shocks for artists, cultural leaders, and support workers in creative industries, the pandemic once again revealed how resilient, stoic, and humanity-focused creative industries participants are when faced with adversity. They exhibit significant *endurance* capacities and a tenacity to survive. While there was serious destruction to the careers and lives of an unknown numbers of artists worldwide, including a huge loss of expertise and labour supply from the sector, many who stayed the course found a silver lining, an opportunity, or achieved personal successes during lockdowns in particular. The landscape for consuming creative content has changed in positive ways, particularly in terms of access and the democratisation of arts and culture. Several of the world's leading cultural producers continue to offer existing, enhanced or new online access opportunities, such as the Berlin Philharmonic's Digital Concert Hall, the Louvre's virtual tours, the Met Museum's range of online resources such as interviews, exhibition tours, and recordings of performances in the gallery, or the National Gallery of Australia's virtual exhibition

tours. Numerous arts festivals around the world also continue to offer online components and experiences in addition to those in-person and live, such as the Edinburgh Fringe Festival.

While those who participated in interviews were willing to share their experiences, it should be noted there are likely countless other artists who would not be willing to unpack their stories given the fatigue associated with discussing the pandemic, or the personal pain they had experienced or were continuing to have to deal with. Similarly, there will be countless numbers of artists who have left their craft or practice behind and moved into other industries, a view echoed by Snowball and Gouws (2022). There will, it is hoped, be many more stories to tell in the coming years about how artists have managed to stay a part of the creative industries sector and how they have responded to creative destruction and disruption, and risen from the ashes.

Artists and arts workers in all areas of the creative industries sector worked fervently to maintain their networks of peers, their connection to audiences, and to present to the world messages of hope, strength, and gratitude. Many felt a sense of moral duty to use their creativity to provide solace to their fellow citizens amidst the chaos and turmoil. The nature of work in the creative industries has changed as a consequence of the pandemic, with forced lockdowns and working from home leading to some creators expressing a preference to continue to work remotely or in hybrid models (Caravella et al., 2023). There is considerable research needed in terms of how future work models will be enacted in various parts of the creative industries sector, with strong arguments for the sector to continue to "experiment with agile practices" (Ryu & Cho, 2022, p. 597).

In addition to shifting work modes, the enormous efforts by large institutions, smaller organisations, creative businesses, and individual artists led to many positives for audiences and end users in terms of new opportunities for the consumption of creative content, increased access and equity, and greater flexibility for audiences in terms of how and when they engage with creative industries. There will no doubt be more initiatives and positive developments in the ensuing years ahead, given artists are never static in their work or their desire to make the world a more informed, cultured, humane, and creative place.

References

Caravella, E., Shivener, R., & Narayanamoorthy, N. (2023). Surveying the effects of remote communication & collaboration practices on game developers amid a pandemic. *Communication Design Quarterly Review, 10*(4), 5–15. 10.1145/3531210. 3531211

Chatzichristodoulou, M., Brown, K., Hunt, N., Kuling, P., & Sant, T. (2022). Covid-19: Theatre goes digital–provocations. *International Journal of Performance Arts and Digital Media, 18*(1), 1–6. 10.1080/14794713.2022.2040095

Csikszentmihalyi, M., & Wolfe, R. (2014). New conceptions and research approaches to creativity: Implications of a systems perspective for creativity in education. In M. Csikszentmihalyi (Ed.), *The systems model of creativity: The collected works of Mihaly Csikszentmihalyi* (pp. 161–184). Springer. 10.1007/978-94-017-9085-7_10

Decrop, A., & Dumont, N. (2023). Innovations in COVID times: Which lessons to learn for the cultural industry? *Journal of Marketing Management, 39*(5–6), 373–388. 10.1080/0267257X.2023.2205424

Gammaitoni, M. (2022). A sociological analysis of the social role of female artists during COVID-19. *Intercultural Relations, 6*(2–12), 123–135. 10.12797/RM.02.2022.12.09

Gnezdova, J., Osipov, V., & Hriptulov, I. (2022). Creative industries: A review of the effects of the COVID-19 pandemic. In V. Osipov (Ed.), *Post-COVID economic revival: Sectors, institutions, and policy* (Vol. 2, pp. 159–171). Palgrave Macmillan. 10.1007/978-3-030-83566-8

Langevang, T., Steedman, R., Alacovska, A., Resario, R., Kilu, R.H., & Sanda, M. (2022). 'The show must go on!': Hustling through the compounded precarity of Covid-19 in the creative industries. *Geoforum, 136*, 142–152. 10.1016/j.geoforum.2022.09.015

Oliver, P.G., & Lalchev, S. (2022). Digital transformation in the music industry: How the COVID-19 pandemic has accelerated new business opportunities. In G. Morrow, D. Nordgård, & P. Tschmuck (Eds.), *Rethinking the music business: Music contexts, rights, data, and COVID-19* (pp. 55–72). Springer Nature. 10.1007/978-3-031-09532-0

Rieple, A., DeFillippi, R., & Schreiber, D. (2023). *Transformational innovation in the creative and cultural industries.* Routledge. 10.4324/9781003207542

Ryu, S., & Cho, D. (2022). The show must go on? The entertainment industry during (and after) COVID-19. *Media, Culture & Society, 44*(3), 591–600. 10.1177/01634437221079561

Saitis, C. (2017). Fractal art: Closer to heaven? Modern mathematics, the art of nature, and the nature of art. In K. Fenyvesi, & T. Lähdesmäk (Eds.), *Aesthetics of interdisciplinarity: Art and mathematics* (pp. 153–163). Birkhäuser. 10.1007/978-3-319-57259-8_8

Sargent, A. (2021, April). Covid-19 and the global cultural and creative sector: Two years of constant learning – New foundations for a new world. *Centre for Cultural Value.* https://www.culturehive.co.uk/CVIresources/covid-19-global-cultural-creative-sector-two-years-constant-learning

Snowball, J.D., & Gouws, A. (2022). The impact of COVID-19 on the cultural and creative industries: Determinants of vulnerability and estimated recovery times. *Cultural Trends*, 1–24. 10.1080/09548963.2022.2073198

Vincent, C. (2022). The impacts of digital initiatives on musicians during COVID-19: Examining the Melbourne digital concert hall. *Cultural Trends*, 1–17. 10.1080/09548963.2022.2081488

White, J. (2023). *Innovation in the arts: Concepts, theories, and practices.* Taylor & Francis. 10.4324/9781003142393

4 Educating Artists and Creatives for a Post-pandemic World

The arts are a core part of education programs, from the earliest years through to university (tertiary) level, in both formal and informal settings. Public and private tertiary institutions are seen as important contributors to arts and culture, acting as vehicles for the preparation of the creative industries workforce, key players in the innovation agenda, and contributors to regional-led development (Cinar & Coenen, 2023). They also play a crucial role in the global cultural landscape through their work in such areas as:

> Hosting museums and/or collaborating with them, mobilizing their resources to guide urban regeneration projects, collaborating with firms in cultural and creative industries, attracting and retaining talent through their science parks and incubators, and developing solutions to societal challenges such as aging and climate change by incorporating cultural elements and creativity. (Cinar & Coenen, 2023, p. 240)

Historically, universities have had a complex relationship with industry, with the goals of higher education in centuries past focused on education for an astute, even elite social class, and to develop enlightened citizens, rather than to create a labour force per se. However, since the latter part of the 20th century, universities in many countries have been increasingly required to demonstrate the employment outcomes for their graduates in order to justify the significant investment of public funds and resources to sustain their operations (Webb & Brook, 2022). Currently, this focus on employment outcomes and contribution to the economy has been strongly endorsed and promoted by governments in the UK, the US, and Australia in particular. This neoliberal and market-driven approach has, however, created significant tensions between those who argue that the core mission of a university education

DOI: 10.4324/9781003434603-5

is to prepare high-level thinkers and enlightened citizens, rather than responding to market forces and demands for work-ready graduates with specific skills.

The unknown longer-term impacts of the current pandemic for future tertiary arts graduates, including equity issues affecting the workforce, are important considerations for the university sector moving forward:

> A further and major absence is the impact of COVID-19 on the [University] sector, and possible futures that may emerge post-pandemic. Of great concern are studies that warn that recent improvements in women's career opportunities may prove to have been diminished by the pandemic and its effects. ... It is vital that monitoring continues to evaluate the gendered experiences of both creative graduates and workers; and to establish more equitable models of education, transition into employment, and inclusive labour market practices. (Webb & Brook, 2022, pp. 135–6)

Webb et al. (2022) point to the importance of much-needed research in relation to where creative industries are heading as the world emerges from the pandemic, and how universities will need to play a vital role in this future, including issues related to gender equity, workforce diversity, and remuneration practices.

The Shift to Online Tertiary Education for Creatives and Artists

In a similar way to creative industries practitioners, the pandemic forced arts educators to urgently shift their work practices to online platforms. Many were faced with a previously unseen paradigm, namely home learning and the need for students to work independently and with minimal interaction with peers, teachers, teaching assistants, or studio technicians. The rapid shift to online learning caused massive challenges for educators, particularly those teaching disciplines where the studio, collaboration, and technical and physical skills are considered essential. For example, performing artists, accustomed to rehearsing in groups for music, theatre, circus, or dance productions, were suddenly faced with having to collaborate and rehearse online using Zoom or Skype, as well as being required to practice their craft in confined spaces at home during lockdowns. The challenges extended to those beyond the performing arts; visual artists, designers, and photographers were suddenly unable to access studios and the often expensive resources needed for

their work, such as materials, 2D and 3D printing, framing, and a range of immersive, alternative reality, and display technologies.

Instruction at the highest level, normally achieved in person, now had to be delivered online and was subject to technical challenges, internet reliability and capacity issues, and large datasets and files which required high-end computing infrastructure with fast and reliable connectivity. For many tertiary educators, it required that they rapidly upskill in online education methods and systems, and often at very short notice. In some cases, this shifted further costs to students, who had to purchase, rent, or borrow materials and equipment to complete their work. Students with low-level or dated hardware and software were often required to expend considerable sums of money to replicate the infrastructure normally available to them while on campus. The pandemic meant a whole new world for tertiary education and, like the broader creative industries, has resulted in the ongoing need to experiment with and establish new paradigms for the education of future generations of workers and cultural leaders.

Preparing Graduates for Success in the Creative Industries

Careers in the arts have always been complex, challenging, fraught, and subject to a range of factors such as an oversupply of labour, under-employment, and highly competitive environments (Daniel & Johnstone, 2017). Careers are typically non-linear and self-driven, and are often strongly influenced by an artist's reputation, networks, and industry experience, rather than creative talent or skill alone. Students who seek a career in creative industries also tend to be more focused on the psychological rather than monetary rewards that it brings (Webb et al., 2022). Despite the significant costs of fees and living expenses that are required to earn a tertiary qualification, students continue to sign up to creative industries courses in significant numbers (Campbell, 2021; Daniel & Johnstone, 2017).

The butterfly effect, discussed in Chapter 2, also offers a metaphor through which to understand creative industries education. It posits that one small flap of the metaphorical butterfly's wings – the point of chaos – can result in major changes elsewhere, with potentially sweeping impacts and disruption for individuals and organisations across the world. Aside from the general disruptions caused by the pandemic, one of the latest impacts of the butterfly effect (and that is not yet fully understood in terms of how it will be managed in tertiary education) is the rise in artificial intelligence (AI) capabilities for the creation of traditional text-based work, as well as visuals, sounds, and creative writing. Direct evidence of the anticipated (yet unknown) future impacts of AI emerged from a 2021 online survey of 19,504 adults aged from 16 to 74,

and from 28 countries, which revealed that 35% of respondents ranked education as the area expected to be changed the most by AI in the next three to five years (Richter, 2023); it was followed by safety (33%) and employment (32%).

The concerns of tertiary art educators about the impact of AI technologies, shared by many practitioners in creative industries (Chapter 3), is perhaps the most significant issue moving forward for higher education. This includes the relationship between how it is used and taught in curricula, and the expectations or realities of how it is used in creative industries. Experiments will continue in terms of its application, which some argue will result in substantial changes in learning and teaching practices (Chiu et al., 2022). Questions abound in relation to its future role in creative industries, although there is an emerging view that rather than devastate parts of the creative industries and education sectors, "AI will be adopted much more widely as a tool or collaborative assistant for creativity, supporting acquisition, production, post-production, delivery and interactivity" (Anantrasirichai & Bull, 2022, p. 639). This view of AI being a tool to use and manage, rather than an existential threat, was also presented by some of the interviewees when asked to consider the ongoing impact of technologies in the sector (Chapter 3).

Tertiary education is regularly at the mercy of government policy and funding structures, which in recent years in many countries – mostly outside Europe – has resulted in major increases in fees, with students in the UK, the US, and Australia, for example, graduating with ever-increasing levels of student debt. Graduates of prestigious institutions in the US, such as the Julliard School, the University of Southern California, the Rhode Island School of Design or Columbia University may leave owing hundreds of thousands of US dollars. Similarly, two of the most expensive institutes in the UK across all fields of study are the University of Arts London and the Royal College of Music, where international students face very high fees in addition to above-average living expenses. In Australia, government higher education policy changes meant that new students in most humanities courses from 2021 were faced with fee increases of 113%, in addition to seeing many subjects cut from their programs including those in creative industries (Wallen, 2023). Funding cuts to arts courses have also occurred as recently as 2021 in the UK, which saw the government halve the subsidy for each full-time arts student by 50% and redirect this money to STEM education (Harris, 2021).

Similarly to creative industries in the public discourse, creative industries education at the university level is regularly subjected to critique and questions regarding its value and place, and use of significant public funds and investment. One of the interviewees for this text, who was head of a department of visual arts in the 1990s at a major public

institution in the US, described how for many years the university "was constantly trying to shut down the department and underfund it". A current educator based in London described how, during the height of Covid-19 lockdowns, their institution launched a strategic plan to focus on "truly modern technical education", with creative industries courses deemed unsuitable for this vision. However, staff at this person's institution worked tirelessly to demonstrate how significant technical principles and practices were core to the learning environment and creative industries curricula. They managed to keep the program from being closed but the interviewee did reflect on the emotional and mental toll that this caused, on top of the day-to-day lived realities and pressures caused by lockdowns.

An artist-academic provided a telling case study of the difficulties that creative industries often face when operating within traditional tertiary education structures, policies, and procedures:

> You know only the other day I had a CEO of a major arts centre here saying 'I've got a space. I want you to fill it' and I went 'great'. It immediately goes up the chain to people saying 'Is this of strategic advantage to the university? Does this meet our strategic priorities?' And I went 'Doesn't matter, it's a space. It's a beautiful space in the city centre. They're offering it to us … and we've got the students who want to present. We don't need any money and we can make brilliant things happen'. But immediately it's strategised and then bureaucratised to the point where you know what used to happen easily becomes a lot more difficult. (Visual artist and academic)

Despite these various issues, as well as the precarious nature of work in the creative industries (Webb & Brook, 2022; Yue, 2022), millions of young people around the world continue to study and strive for a fulfilling career in creative industries (Campbell, 2021), resulting in an ongoing oversupply of labour to an already saturated and highly competitive market. With career paths characterised by short-term, sporadic, project-based, and seasonal employment, creative industries graduates are usually required to undertake both paid and unpaid work, often in areas that are outside their preferred discipline and seemingly at odds with their preferred creative goals. Competition for high-level internships, residencies, grants, and scholarships is intense, with networks and industry connections often as important as artistic skills and knowledge. A creative industries practitioner's identity can be challenged in an

ongoing way as they navigate the shifting and complex creative industries landscape.

The Covid-19 pandemic has exacerbated the multitude of challenges that arts graduates face, both now and into the future as creative industries set out to rebuild and to restore confidence in the live or in-person audience market. This is also a range of current and potential future austerity measures which are likely to have a further negative effect on the sector, given the massive amounts of national debt that have accumulated in most countries since 2020. The pandemic has unquestionably accelerated the need to rethink and revisit tertiary education, given the changing nature of work and practice in creative industries, and the reality is that the future landscape will be substantially different to what it was before the pandemic took hold, therefore requiring new skills, knowledge, and capabilities, but also offering new opportunities.

Covid's Impact on Tertiary Education for Creatives and Artists: Disruptions and Chaos

As cited previously, the pandemic had significant and immediate effects on tertiary education. Many public institutions, forced to find budget savings, looked at reduced funding to creative industries programs – or in the case of some institutions, even closed them entirely (Pennington & Eltham, 2021, p. 39). Covid-19 also required that educators were motivated to develop and embrace mixed learning methods, especially through online platforms, and this has opened up many opportunities for students to continue their studies around their other work and life commitments. Shifts in industry to present creative content online (such as virtual exhibitions and live streaming of performances) enabled educators to bring new content into the curriculum and expose students to arts practices from around the globe. The pandemic has also challenged the whole nature of tertiary education, in terms of finding the appropriate mix of in-person and virtual learning activities. This determination of what is an appropriate mix continues to unfold, with the virus still lurking in the shadows and many students now accustomed to online learning systems and working from home.

Educators not only shifted rapidly to the use of online platforms such as Blackboard, Moodle, or Canvas, but many also added social media platforms to their learning such as TikTok and WhatsApp or applications such as Bitmoji. They also adopted or adapted gaming and simulation tools, as well as building short courses and micro-credentialing programs. Stronger relationships between tertiary education and creative industries were also argued as essential once the pandemic took hold – for example, Giusti (2023) refers to the need for education institutions

to work even more closely with the gallery and museum sector in order to provide students with opportunities to expand their knowledge, networks, and industry insights.

Early Research Studies: The Impact of the Pandemic on Tertiary Education

Lee et al. (2022) highlight the specific and very significant challenges that tertiary providers faced in the performing arts disciplines such as music, where instrumental lessons, orchestral studies, and chamber music (for example) had been taught in face-to-face mode for centuries and relied on multi-sensory learning. In their writings about the situation in Korea, Lee et al. (2022) describe how in lockdowns educators adopted distance, remote, and socially distanced learning methods. The authors completed interviews with 14 music instructors from five different Korean universities. Teachers discussed how they made rapid shifts to online and remote learning platforms, developed new technological skills, learnt more about their students and how they work, and put in place multimodal methods to keep learners engaged. Lee et al. (2022) also highlighted the various challenges that teachers had to overcome to make these substantial shifts in delivery and learning opportunities.

In relation to dance and ballet, Warburton (2022) refers to the fact that during pandemic lockdowns, dancers had no option but to "digitize their bodies online" (p. 1). Warburton (2022) hence argues that it is critical that university educators and students in dance engage with digital arts and social media, including "digital dance content and curation, critique and analysis" (p. 10). Lee et al. (2022) also argue that higher education and its educators will, in future, need to embrace the advantages of both in-person instruction and digital learning, and that "education in the post pandemic world is going to be different from the pre-COVID-9 [sic] in many ways" (p. 314). A visual arts interviewee also commented on the importance of education being increasingly available to not only tertiary art students but to the general public through digital means and using social media platforms: "I believe that education should be shared and it should be accessible. The more accessible it is, the more valuable it becomes".

Li et al. (2022), conducted a study exploring the rapid shift in education at the Hong Kong Academy of Performing Arts to hybrid models of learning, including both synchronous and asynchronous models. In gathering survey data from students and academics, the researchers were able to identify that there was moderate-to-high adoption of online learning practices, despite WiFi connectivity being problematic. However, they also found that delivering content only (one-way transmission with no interaction) was not as effective as creating virtual spaces for students to

interact and collaborate. The use of video recordings made by students was seen as valuable for both self-reflection and peer feedback. There was, however, a majority of students who felt that, overall, practical classes were best delivered in face-to-face mode.

Li et al. (2022) also argue the need to rethink careers and to further emphasise employability and entrepreneurship, reaffirming that graduates will need to manage multiple identities and stressors. Their research reiterates the fact that post-pandemic life will involve stark contrasts between individual goals and aspirations and the rapidly changing context in which people are required to work and to practice their art or craft. Li et al. present the case for greater attention towards meaningful work and social justice approaches to career education, as well as an eco-oriented approach to pedagogies, curricula, and careers given the enormous environmental challenges on the horizon due to climate change.

The discourse suggests that there are unknown possibilities surrounding the potential for live music-making and recording using online platforms, and that should inform tertiary education programs. These various issues as they apply to higher education are discussed by Tolmie (2020), who contends that there are currently significant problems that musicians encounter when working online, including latency, bandwidth, as well as cost. In time, it is likely that these issues will either be improved significantly or resolved. Tolmie (2020) also discusses strategic foresight, megatrends and post-normal times; "higher music education is required to adapt, and continue to adapt, by including digital literacy and futures thinking training" (p. 606). Tolmie proceeds to present the following framework and adaption of Hajkowicz's (2015) global megatrends as being important for tertiary education to embrace, and being of relevance to any discipline of practice in creative industries:

1 *More from less* – increasing demand for limited natural resources;
2 *Going, going … gone?* – a window of opportunity to protect biodiversity, habitats, and the global climate;
3 *The Silk Highway* – rapid economic growth in Asia and the developing world;
4 *Forever young* – an ageing population, changed retirement patterns, chronic illness, and rising healthcare expenditure;
5 *Virtually here* – digital technology is reshaping retail and office precincts, city design and function, and labour markets;
6 *Great expectations* – consumer and societal expectations for services, experiences and social interaction; and
7 *The innovation imperative* – technological advancement is accelerating and creating new markets and extinguishing existing ones.

Although Tolmie (2020) does not go into detail as to how these mega-trends might inform the future of education at the tertiary level, it certainly points to the importance for key stakeholders in creative industries and tertiary education to pay careful attention to these trends when considering future-oriented curricula. There is a strong argument that tertiary educators need to look to reconceptualise, not simply return to pre-pandemic programs.

Canham (2023), also examining music in tertiary education, raises a tension in that "there are some uncomfortable truths and uncertainties about the ways in which music careers are envisaged and experienced that might be faced" (p. 4). She refers to how "unworkable" music careers have become, how mental health issues have been amplified due to the pandemic, and that returning to what was considered normal is unwise. Those in music who were on contracts, freelance, or who worked casual hours have been far more affected than those in full-time positions, hence Canham (2023) argues that those in education need to "teach our students how to make more effective connections between what they aspire to do versus what is needed" (pp. 5–6). Young people have been wounded (Canham, 2023) by the pandemic in ways that are yet to be seen from a longer-term perspective; rapid rather than incremental change is therefore needed.

Canham (2023) also makes the point that neoliberalism in the arts results in workers who concentrate on themselves and commercial rewards; however, she contends that during the pandemic this paradigm failed many workers and has been linked to "widening inequality, maintaining gender and racial disadvantage, discrimination, and a global North/South divide" (p. 7). Canham presents strong arguments for higher education to put in place mechanisms and learning that require students to shift their focus from themselves and their talent development, to look more broadly at the music field, and to more closely consider issues surrounding ethics, morals, and ecological concerns.

Howard et al. (2021) refer to the increased pressures on young people caused by lockdowns, in terms of the loss of work, career disruptions, shocks, and unknowns, and external pressures that are likely in the future, such as economic instability, changes to supply and demand models, regular periods of unemployment, and ongoing disruptions to the creative industries sector. Matei and Ginsborg (2020) argue that health education should be an area of focus in preparing musicians in particular for a career in creative industries, particularly in terms of strategies to deal with physical pain caused by long hours of practice and performance, and the management of anxiety, with both health ailments common to the music sector. This notion of health education has particular relevance to all disciplines in the

performing arts, be this music, dance, theatre, and other forms of artistic performance.

Resario et al. (2023) posit the need to reframe the resilience discourse, which is frequently argued by policymakers, that individuals need to take responsibility for their ability to bounce back from adversity, and those who cannot have essentially failed. In their study, they focus on the practice of resilience and argue it is critical at the university level so that students are afforded a safe space to explore "the diversity of ways in which people cope with, rework, and resist the challenges of their lives" (Resario et al., 2023, p. 17). As discussed in Chapter 1, Adelman (2021) however argues for a shift in focus from the negative-oriented concept of resilience to *endurance*, a personal quality required for a sustained career in a sector which is subject to regular shocks and disruptions.

A New Approach to Tertiary Education for the Creative Industries

The pandemic has disrupted global creative industries and education at all levels. This shake-up means a different future, and tertiary educators continue to need to work quickly and tirelessly to reset and reimagine their creative industries programs. Past practices of spending years isolated in studios and with little connection to industry, community, and other areas of the economy is no longer a reality when looking towards the next generation of workforce aspirants. While some traditional areas of practice will continue to use centuries-old models that remain highly effective, such as the atelier studio approach, or the one-to-one music lesson, new methods of production, dissemination, and consumption of creative content have permanently changed creative industries and the future world of work that graduates will need to navigate. It is argued here that, based on the impact and change caused by the pandemic and ongoing calls in the academic literature and discourse, in addition to discipline-specific knowledges and skills, tertiary arts educators need to pay critical attention to the following five areas, as outlined in Figure 4.1. These areas are relevant to the future for creative industries, and will enable graduates to be further prepared for the chaos inherent to the sector and any ripple effects caused when the butterfly flaps its wings again:

- Eco-focus and sustainability
- Ethics and morals
- Non-arts knowledge, skills, and capabilities
- Alternative indicators of success
- Personal management and care

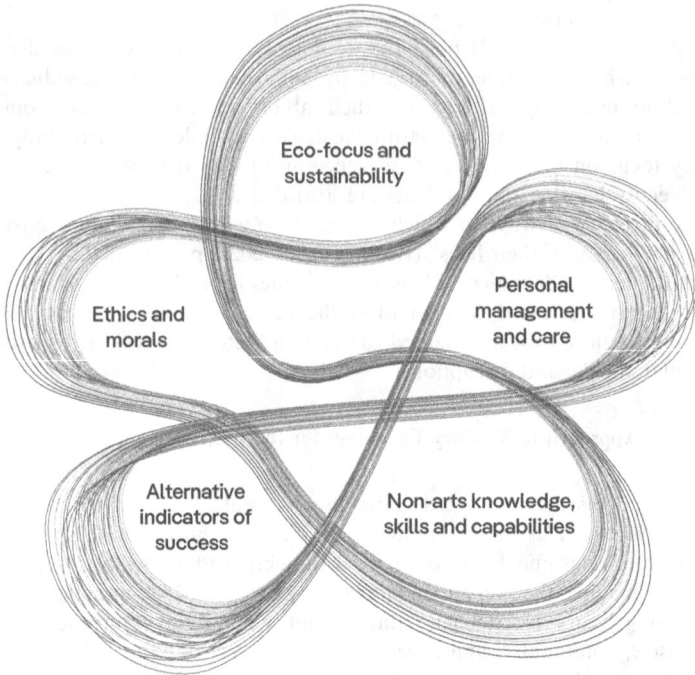

Figure 4.1 Eileen Siddins (2023). *The Future for Creative Industries Education* (author title).

Eco-Focus and Sustainability

The younger demographic is acutely aware of the climate change crisis. There is a genuine sense of foreboding in the hearts and minds of emerging generations, evidenced in the discourse, in reports of activism, and in genres such as cli-fi literature and cinema. Tertiary arts educators therefore need to look closely at how creative industries can play a leading role in environmental communication and debate, using storytelling, images, sounds, and interactive experiences. As Alexander (2023) describes, "creative arts projects can help us imagine how the climate crisis might play out, and what the human response could be" (p. 75). He cites photography as a powerful tool by which to "effectively communicate the details, scale, and impacts of the Anthropocene, even using different photographic techniques and technologies to reveal information that often escapes the human eye" (Alexander, 2023, p. 75). Significant initiatives and positive approaches

to climate change such as the solarpunk art and fiction movement could be embraced and explored within curricula, including how such a movement has enabled artists to see how they can use captured carbon materials in art (Alexander, 2023). Creative industries aspirants also need to be made aware of broader trends in economies, infra-structures, and social patterns, in order that they might align their creativity to the world as it rebuilds from various crises.

Creative industries educators, and tertiary education as a whole, need to look ever more closely at the sector's carbon footprint. Universities house massive amounts of infrastructure, requiring power, connectivity, heating or cooling, maintenance, use of chemicals for cleaning, and ex-tensive waste systems. Art schools create considerable volumes of waste, such as chemicals, paints, and disposable products such as specialist papers and material offcuts. The combined carbon footprint of global tertiary education infrastructure is considerable, and for creative indust-ries education this not only includes standard teaching spaces but often large and energy-intensive facilities such as galleries, museums, and performing arts centres. Tertiary students need to feel that they are contributing to the discourse and strategies designed to slow the current rapid pace of climate change and to reshape the world to become increasingly focused on sustainable practices and ideologies. They need to be encouraged to use "Artivism" as a form of demonstration and for drawing attention to the critical junctures that the world is heading to-wards as a consequence of environmental destruction. Providing tertiary students with genuine agency around climate action and the power of art to contribute to social awareness and change should be given significant priority moving forward.

Ethics and Morals

Younger generations are very aware of the various social issues that are relevant to creative industries, including the democratisation of (and importance of equitable access to) art, and the ethics associated with sponsorship of arts institutions and events by companies engaging in greenwashing or other questionable practices. They are also aware of the funding models that are heavily skewed to large global organisations and platforms such as Apple, Spotify, YouTube, and TikTok, and the imperative that these global heavyweights have a moral responsibility to be more equitable in the way they return royalties to the creators of the content from whom they are earning billions of dollars in revenue. There is well-established dissatisfaction amongst practitioners who put their work on online platforms in relation to the royalties that are returned to them. Students at tertiary level need to learn about this situation, to look at how they might have agency in pushing a different agenda, and to

understand the various metrics associated with streaming platforms and their algorithms.

Future creative industries graduates need to be involved in looking at ways of making strong statements around environmental ethics and moral standards, be this in the selection, responsible use, and disposal of art materials, or in terms of using artforms to communicate the imperatives associated with renewable energy, stewardship of resources, and the environmental destruction caused by the massive volumes of plastics in waterways and oceans, for example. The necessary medical and health-related waste resulting from the pandemic has created a new and significant environmental issue, and exposed the global health system's inability to effectively manage the huge amount of discarded personal and protective equipment (e.g., masks) and test chemicals (World Health Organisation, 2022). Artists have the opportunity to visualise and communicate the imperatives around these and many other urgent moral and ethical issues.

Non-arts Knowledge, Skills, and Capabilities

The pandemic has reignited debates in relation to the need for tertiary arts educators to embed a strong focus on non-arts knowledge and understanding in their courses. While for decades this has often centred on entrepreneurship capabilities, the future sector is a far more complex and nuanced system characterised by rapid change, technological revolutions, changing audience patterns, and new possibilities for creator-consumer engagement. The importance of having an entrepreneurial attitude or outlook has been contentious for decades in relation to those who seek a career in creative industries, and although it has some relevancy, it is arguably a dated concept when considering the changing world of work. Graduates need to understand the complex system that is the creative industries, which is expertly defined and explained in the systems model of creativity by Csikszentmihalyi and Wolfe (2014). This system involves particular idiosyncrasies in terms of business models and supply chains, which require different nuances and value propositions, especially in terms of what becomes established as the new normal (Lin, 2023).

Graduates should also understand the principles of chaos theory (Saitis, 2017), which is particularly pertinent to the creative industries as a sector subject to both small and major changes at any point in time. For example, a visual artist seeking to enhance their profile in the gallery sector might be successful in securing a solo exhibition in a reputable gallery. A seemingly small flap of the butterfly's wings can lead to major positive outcomes, including in-gallery and ongoing sales of artworks, commissions for new artefacts, invitations to exhibit in other galleries, positive media reviews, and a significantly enhanced reputation. On the

other hand, the butterfly effect can result in negative impacts, including poor reviews of the work, minimal to nil sales, considerable reputational damage, and a significant impact on the artist's sense of value and self-worth. Graduates will therefore need to face and deal with wicked problems, they will need to embrace constant change, and have well-developed *disruption capabilities* – the ability to prepare for, deal with, and respond to various forms of chaos, uncertainty, and change.

Although the traditions of analogue arts practices will remain essential to creative industries and tertiary education, there is an imperative to look closely at skills that graduates will need for the post-pandemic economy, particularly in terms of digital and industry skills. Graduates need to be able to understand and apply the principles of strategic foresight, engage in career planning, and develop a well-grounded assessment of the realities of working in creative industries. Although there is merit in encouraging aspiring creatives to dream about becoming the next Hollywood icon, pop music superstar, best-selling author, or visual artist with an international exhibition profile, students need to be gently – or, at times, more firmly – reminded as appropriate that these successes are extraordinarily rare. They also need to be comforted that a rewarding and viable career in creative industries can be achieved and determined by the individual in the context of their human, intellectual, and creative needs (Moxey & Daniel, 2023).

In a similar way to the millions of young children who aspire to be a sporting superstar in tennis, golf, swimming, or football, it is only a select few artists who reach global stardom – and this goal should not be the most important priority or measure of success for those in creative industries. Tertiary educators need to focus on reframing the concept of success and how this should be driven by the individual, and not subject to media-driven hype, cultural stereotypes, or past models and indicators of success. Future graduates should be supported to be ambitious but equally supported to fail, reset, and rebuild. Creative industries aspirants need to construct a long-term vision and strategic approach, given the years and in some cases lifelong commitment that is required to realise a creative vision or dream. The concepts of self-determination and self-actualisation should be explored and embedded in learning systems. This is increasingly important for those seeking careers in creative industries, given the well-documented higher levels of mental stress and mental illness in the sector, which are likely to be exacerbated for many years as a result of the creative destruction and generational change caused by the pandemic.

Alternative Indicators of Success

Stereotypes and indicators of success in creative industries need to be challenged and reframed (Moxey & Daniel, 2023). The importance and

value of community arts and contributing to the building of community through art and creativity, of the value of grass-roots education, and the importance of periods of non-employment in order to dive into intense creative productivity should be encouraged and supported, and not seen as times of failure. The social benefits and healing that creative industries practitioners provide should be valued as significantly as a best-selling album, sold-out performance, standing ovation, prize-winning work of visual art, or record-breaking book sales.

Aspiring graduates should be taught to discern between individual or personal measures of success, and be empowered to reject society's stereotypes and often unrealistic media-driven measures of value and achievement. The media is quick to report on and lavish praise around the latest global tour by a popular music superstar, but why should this be any more a measure of success than the achievements of an artist who supports disadvantaged communities to learn to heal through the process of engaging with and making art? In what might seem like simple ways, these "silent" artists may help a person's identity management, their sense of purpose, or even prevent them from engaging in self-harm or more devastating outcomes for themselves and others. Lockdowns have reminded societies that engagement with art and culture is a critical means by which individuals and societies can find solace and comfort during times of horrendous crisis, hence educators have an important role in reminding students of this phenomenon and its critical importance both in the past, during the current pandemic, and for the future.

Personal Management and Care

Future creative industries graduates will need to manage complex and changing personal and professional identities, given they will have longer careers than previous generations due to advances in healthcare and rising retirement age thresholds. They will need to determine their goals and preferences for stability, variety, personal reward, and choice of employment(s) on an ongoing basis, as well as nurturing important personal relationships, family connections, and peer support systems. Educators should be cognisant of the ways in which positive mental health can be discussed, taught, and fostered. Emotional and psychological health should be addressed, particularly given the damage caused by the pandemic, and students made well-aware of the support systems that they can access.

Similarly, physical health should receive much greater attention in tertiary arts programs, given the absolute necessity for physical fitness in the performing arts in particular. Educators should raise awareness with their students of the importance of preventative care, given the potential for those in the physical arts to suffer regular and career-ending injuries.

This includes musicians and vocalists who strain muscles and joints; dancers, circus artists, and acrobats who place enormous physical stress on their body and who are at a high risk of injury; actors who may need to be working in challenging environments and film sets; and various creatives who engage in extensive field work (e.g., landscape painters and photographers, underwater videographers, ethnographic researchers in developing countries, and those who gather data outside the academy), requiring that they have high levels of fitness and agility, awareness of safety and cultural protocols, and the capacity to manage risk. In drawing another parallel to sport, there are countless numbers of aspiring creatives whose careers are thwarted or even ended as a result of emotional or physical injury. Although the time needed to embed these important areas within tertiary education is limited, it is argued here that they should receive as much attention as the development of artmaking and presentation skills.

Conclusion

Tertiary education continues to play a critical role in contemporary life, in terms of the development of vibrant cultures and societies, with artists and creatives learning from great masters, mentors, peers, and through life-changing experiences in conservatoires or art schools. An education for the creative industries has been proven to bring many benefits to individuals, enabling aspiring creatives to further develop skills in creative thinking and imagination, and to develop the discipline and persistence associated with the years and thousands of hours required to perfect a skill or complete a major creative work. Art is an incredible vehicle by which individuals can develop inner strength, realise their passion, and make a difference to others' lives. Many artists and creatives are intensely motivated, persistent, resilient, and passionate individuals, with a great sense of concern for humanity, the earth, and future generations. These wonderful attributes need to be fostered and nurtured by tertiary arts institutions and educators.

Those involved in tertiary education are now in the midst of another phase of creative destruction and disruption – one which requires that institutions and their staff embrace new imperatives, and reconceptualise programs rather than simply wait and hope to return to previous models. Covid-19 has permanently changed contemporary society, and although a respect for the past and its great artists is essential, it is equally essential that graduates are prepared for a very different future and creative industries sector. The ongoing integration of education with industry and community also remains as important as ever, as does the importance of both educating and reminding audiences and societies as to the value of the arts – this value having been

brought to the fore once again during lockdowns. Political leaders should also play a far greater role in promoting, encouraging, and supporting creative industries education into the future, as a key part of global recovery initiatives and strategies.

Added to this urgent agenda is the current catastrophe that is climate change, which the world needs to respond to more rapidly and ruthlessly. As Alexander (2023) describes:

> It is too late now for colleges and universities to begin preparations for a far-off [environmental] danger. The crisis is already upon us. We are advancing ruthlessly into the Anthropocene. Fires now burn on academia's horizon. It is up to us to choose if those will be flames of destruction or the lights of illumination. (Alexander, 2023, p. 226)

The next generation of artists and creative industries workers can and should play an important part of this agenda of healing and saving our world. Tertiary arts and creative industries education is therefore a key vehicle for supporting these future generations and for using art and creativity as a powerful tool for change.

References

Adelman, R. (2021). Enduring COVID-19, nevertheless. *Cultural Studies, 35*(2–3), 462–474. 10.1080/09502386.2021.1898014.khy

Alexander, B. (2023). *Universities on fire: Higher education in the climate crisis.* Johns Hopkins University Press.

Anantrasirichai, N., & Bull, D. (2022). Artificial intelligence in the creative industries: A review. *Artificial Intelligence Review, 55*, 589–656. 10.1007/s104 62-021-10039-7

Campbell, M. (2021). Reimagining the creative industries in the community arts sector. *Cultural Trends, 30*(3), 263–282. 10.1080/09548963.2021.1887702

Canham, N. (2023). Living with liminality: Reconceptualising music careers education and research. *Research Studies in Music Education, 45*(1), 3–19. 10.11 77/1321103X221144583

Chiu, M.C., Hwang, G.J., Hsia, L.H., & Shyu, F.M. (2022). Artificial intelligence-supported art education: A deep learning-based system for promoting university students' artwork appreciation and painting outcomes. *Interactive Learning Environments*, 1–19. 10.1080/10494820.2022.2100426

Cinar, R., & Coenen, L. (2023). Universities' contribution to culture and creativity-led regional development: Conflicting institutional demands and hybrid organizational responses. *Industry and Higher Education, 37*(2), 237–250. 10.1177/ 09504222221119736

Csikszentmihalyi, M., & Wolfe, R. (2014). New conceptions and research approaches to creativity: Implications of a systems perspective for creativity in education. In M. Csikszentmihalyi (Ed.), *The systems model of creativity: The collected works of Mihaly Csikszentmihalyi* (pp. 161–184). Springer. 10.1007/978-94-017-9085-7_10

Daniel, R., & Johnstone, R. (2017). Becoming an artist: Exploring the motivations of undergraduate students at a regional Australian university. *Studies in Higher Education, 42*(6), 1015–1032. 10.1080/03075079.2015.1075196

Giusti, S. (2023). Museums after the pandemic, from resilience to innovation: The case of the Uffizi. *International Journal of Cultural Policy.* 10.1080/10286632.2023.2167986

Hajkowicz, S. (2015). *Global megatrends: Seven patterns of change shaping our future.* CSIRO. https://bit.ly/44q72CU

Harris, G. (2021, July 20). UK government approves 50% funding cut for arts and design courses. *The Art Newspaper.* https://www.theartnewspaper.com/2021/07/22/ukgovernment-approves-50percent-funding-cut-for-arts-anddesign-courses

Howard, F., Bennett, A., Green, B., Guerra, P., Sousa, S., & Sofija, E. (2021). 'It's turned me from a professional to a "bedroom DJ" once again': COVID-19 and new forms of inequality for young music-makers. *Young, 29*(4), 417–432. 10.1177/1103308821998542

Lee, I., Auh, Y., & Lee, E. (2022). Emerging reform of higher education in post pandemic. In V. Dennen, C. Dickson-Deane, X. Ge, D. Ifenthaler, S. Murthy, & J. Richardson (Eds.), *Global perspectives on educational innovations for emergency situations* (pp. 305–315). Cham: Springer. 10.1007/978-3-030-99634-5_30

Li, Z., Li, Q., Han, J., & Zhang, Z. (2022). Perspectives of hybrid performing arts education in the post-pandemic era: An empirical study in Hong Kong. *Sustainability, 14*(15), 9194. 10.3390/su14159194

Lin, A. (2023). Emerging key elements of a business model for sustaining the cultural and creative industries in the post-pandemic era. *Sustainability, 15*(11), 8903. 10.3390/su15118903

Matei, R., & Ginsborg, J. (2020). Physical activity, sedentary behaviour, anxiety, and pain among musicians in the UK. *Frontiers in Psychology, 11*, 3354. 10.3389/fpsyg.2020.560026

Moxey, L., & Daniel, R. (2023). Reimagining careers in unpropitious creative fields through the meta-creativity of alternative creativity: Implications for the music industry. *Creativity Studies, 16*(1), 241–254. 10.3846/cs.2023.14916

Pennington, A., & Eltham, B. (2021). Creativity in crisis: Rebooting Australia's arts and entertainment sector after COVID. *The Centre for Future Work at the Australia Institute.* https://apo.org.au/node/313299

Resario, R., Steedman, R., & Langevang, T. (2023). Exploring everyday resilience in the creative industries through devised theatre: A case of performing arts students and recent graduates in Ghana. *International Journal of Cultural Studies.* 10.1177/13678779231163606

Richter, F. (2023, February 1). How will AI change our lives? [Digital image]. https://tinyurl.com/5n8dzf4n

Saitis, C. (2017). Fractal art: Closer to heaven? Modern mathematics, the art of nature, and the nature of art. In K. Fenyvesi, & T. Lähdesmäki (Eds.), *Aesthetics of interdisciplinarity: Art and mathematics* (pp. 153–163). Cham: Birkhäuser. 10.1007/978-3-319-57259-8_8

Tolmie, D. (2020). 2050 and beyond: A futurist perspective on musicians' livelihoods. *Music Education Research*, *22*(5), 596–610. 10.1080/14613808. 2020.1841133

Wallen, C. (2023, May 4). A 'carrot and stick' approach to university degrees isn't deterring students from studying humanities despite higher fees, academics say. *ABC News*. https://www.abc.net.au/news/2023-05-04/qld-university-humanities-hecs-fees-help-fees-study-costs/102294428

Warburton, E. (2022). TikTok challenge: Dance education futures in the creator economy. *Arts Education Policy Review*, 1–11. 10.1080/10632913.2022.2095068

Webb, J., & Brook, S. (2022). Conclusion: Universities and the CCIs. In S. Brook, R. Comunian, J. Corcoran, A. Faggian, S. Jewell, & J. Webb (Eds.), *Gender and the creative labour market: Graduates in Australia and the UK* (pp. 125–140). Cham: Springer International Publishing. 10.1007/978-3-031-05067-1_6

World Health Organisation. (2022, February 1). Tonnes of COVID-19 health care waste expose urgent need to improve waste management systems. https://www.who.int/news/item/01-02-2022-tonnes-of-covid-19-health-care-waste-expose-urgent-need-to-improve-waste-management-systems

Yue, A. (2022). Conjunctions of resilience and the Covid-19 crisis of the creative cultural industries. *International Journal of Cultural Studies*, *25*(3–4), 349–368. 10.1177/13678779221091293

Conclusion

The Covid-19 pandemic represents the most recent wave of creative destruction impacting global societies and economies. Creative industries were, without question, one of the most heavily damaged and impacted areas, and although the initial flap of the butterfly's wings seemed innocuous at first, it quickly grew into a global wildfire of destruction, leading to devastating losses and fallout around the world. This catastrophic loss was initially in terms of human life; it lingers still for those who grieve loved ones and those now living with the virus in terms of long Covid. People lost their homes, families and marriages were stressed or even broken, and the mental health of individuals and societies was severely tested. There was also devastation to millions of careers, to livelihoods, and employment prospects, with the world still continuing to recover while trying to determine where its future work and workforce might be.

The creative industries sector responded as quickly as it could during 2020 and has continued to do so ever since. It suffered many devastating blows but also became a source of refuge for millions of those who looked to creative content when in dark times. The first year of the pandemic in particular was a reminder of the ways in which engaging with the arts and with creativity can provide a means of solace, refuge, and escape, with significant evidence of increased engagement with the arts both during lockdowns and in the years since 2020. It was also a reminder for political leaders and policymakers about how important arts and culture are for the health of societies during times of great trauma and turmoil.

The stresses that the pandemic have caused have been remarkable and there would be few who did not feel its impact in some way. Despite this, the artforms that are core to the creative industries, most notably music, visual arts, theatre, dance, photography, film, and literature, provided the material and experiences for individuals of any age, race, and gender to take a mental break while the world was in chaos. The music associated with a great emotional moment or a memorable film sequence,

DOI: 10.4324/9781003434603-6

precious family photographs hidden away in albums and cupboards, a favourite childhood story, or a piece of art either gifted or purchased became heightened points of connection to one's own emotions, to others, and to humanity. Many also gravitated to making new creative work, to redecorating the home, and to learning new ways by which to engage with the world of art and creativity.

Although it had devastating impacts for artists and arts workers – and there would be countless losses in terms of passionate creative individuals who were either forced or chose to abandon their craft in order to find other ways to survive financially, spiritually, or emotionally – there are also positive stories of how lockdowns enabled artists and creatives to find ways through and out of the chaos. Like some of the general public, some artists were fortunate enough to be able to use the time to heal, pause, or simply rest. Lockdowns or periods of furlough also enabled many to complete unfinished work and projects. Others used the unexpected free work hours – largely due to reduced commute times – to reshape their brand and online presence, build new audiences, establish new networks and collaborations, or focus on new creative projects and outputs. The resilience, determination, endurance, and strategic foresight of those in the sector was once again brought to the fore.

Artists in history have been key to creating great works in response to crises, and this has again been the case with Covid-19. Although the field is yet to determine which creative artefacts will be regarded as the pinnacle of works created in the 2020s, and there will be many more created before the end of the decade as societies continue to emerge from the polycrisis the world is dealing with, artists will be critical players and communicators relevant to how the world remembers the Covid-19 pandemic and other crises of the time. Great artworks take many years to find their way into the canon or the list of the great creative artefacts; hence, the passage of time is needed before we can determine which works will be lauded as those that mark this point in history. Although the media and contemporary discourse has reported on the work of high-profile artists such as Bob Dylan, Banksy, and Taylor Swift in creating art that is an important response to the time, there will be thousands of other artefacts in existence that the general public is unlikely to have seen as yet and that the field will determine a place for in future.

Artists and creators are typically innovators, and the pandemic accelerated numerous new experiences for audiences, particularly in the online space – be this in terms of institutions and artists adding content to their existing online presence, or the development of new ways for audiences to engage and participate in culture. The explosion of new material included accelerated explorations into the use of augmented and virtual reality, to new initiatives in creator-consumer-creator interaction. It also included (where possible) increased use of

public spaces for free and ticketed live and (semi)permanent creative performances or displays, where audiences could socially distance and determine their level of safety and comfort. The mural, street art, and the drive-in cinema have had somewhat of a revival in recent years. Despite the numerous global crises at present, there is somewhat of a greenfield site for creative industries in the years ahead.

The pandemic has also meant that there have been major disruptions to tertiary education for artists and creatives, as well as the next generations of creative industries workforces. Courses at all levels have involved further use of online spaces and technologies, and although there has been a return to in-person learning experiences, effective models for online delivery have been experimented with and adopted at length. Some have succeeded and some have failed or been rebuilt, changing the landscape for education. This shift has further democratised education and created opportunities for people beyond the major centres that they may not have had access to previously. Educators preparing graduates for creative industries will continue to have to work through the current period of creative destruction; indeed, the impact of and potential for AI and alternative realities (AR and VR) is far from resolved. Like any disruptive technology, it will take time for the education sector to determine how and where these might have a place in the next phase of ongoing preparation of enlightened minds and creative industries participants.

Future Gazing

There are numerous unknowns for the creative industries in terms of what the future involves. One area that continues to find its (revised) place and health protocols is that of in-person events and experiences. Although there has been a steady return to in-person experiences, the potential for future outbreaks of the virus remains, as do the concerns for some audience members in relation to attendance at events and the potential health risks, particularly for those with long Covid or weakened immune systems. Numerous questions arise:

- Will the sector rely on its audiences to self-assess the extent to which they might exhibit Covid-like symptoms and thus avoid in-person events?
- Will masks and social distancing protocols have an ongoing role to play at venues?
- Will there be a continuing shift to last-minute tickets in order that audience members can monitor their health closer to the event? Or will new ticketing systems emerge where an audience member might provisionally reserve a ticket but not be required to commit funds until closer to the event, or switch at the last minute to a paid streamed

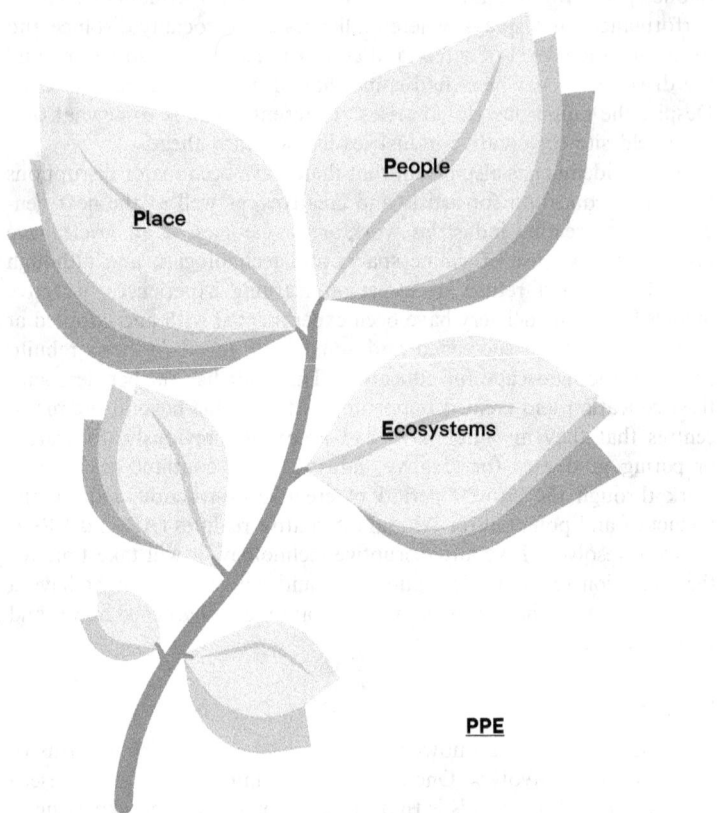

Figure C.1 Eileen Siddins (2023). *Creative Industries Futures* (author title).

version of the in-person event to avoid the potential for passing on any infection?
• What research data are needed about the attitudes and consumption patterns of the younger generations in relation to how they will shape the future for in-person creative industries offerings?

Going forward, these issues and questions are important for creative industries audiences, organisations and venues in order that the sector can continue to rebuild quickly and safely.

When reflecting on the recent discourse, academic research to date, and in particular the views of the 35 creative practitioners interviewed as part of Chapter 3, I spent considerable time adopting a future-gazing

approach and reflecting on where creative industries may head in the next period of time. Personal protective equipment (PPE) remains absolutely critical in dealing with the health impacts caused by the pandemic; this same acronym represents the basis of what I propose are three important themes for academics, educators, cultural leaders, audiences, and key stakeholders in the creative industries to focus on over the next period of time: "people, place, and ecosystems". It is also beautifully fitting that the sequence of words in the acronym are, in this author's opinion, in priority order. "People" are the most important and critical asset, "place" is of vital personal and professional significance for creative industries activities, and "ecosystems" are a set of structures that are established, innovated, and sustained by these people and places. This model is visually represented in Figure C.1.

People, Place, Ecosystems

Under these three themes are critical subthemes, after which it is intended that the reader might imagine how this relates to them and their future in creative industries, as either creator, consumer, cultural leader, or one of the many other roles inherent to a healthy and vibrant sector. There is also a gamut of research opportunities to pursue in relation to current global crises and the creative industries, with these areas and themes all ripe for further exploration and interrogation.

People

Relationships

The following reciprocal relationships amongst people drive and sustain creative industries, and are deemed critical in terms of them being supported, nurtured, and valued:

- Creatives and creatives – the ways producers of creative content relate to and work with each other.
- Creatives and audiences – interactions and transactions between producers of creative content and their consumers or users.
- Audiences and art – attitudes towards the value of the arts and the importance of audiences for making art come alive.
- Gatekeepers and creatives – cultural leaders' roles in working both with and for creatives.
- Gatekeepers and audiences – the importance of cultural leaders' championing of their audiences, and listening to and responding to them.
- Cultural leaders and government – the importance of effective relationships in such areas as policymaking, funding decisions, value propositions, and communications domestically and internationally.

Experiences

It is essential that structures are put in place to support passionate creatives to achieve their goals and ambitions for presenting work to the public. Equally important are the audiences for creative work, who play a vital role in engaging with this work, including:

- **In venues** – as live events continue to return, the manner in which these take place needs careful and ongoing consideration to maximise the consumer experience.
- **At home** – these experiences need to be authentic, mutually beneficial, and ongoing in order to maintain and increase access opportunities.
- **Virtual** – the development of advanced and interactive online, immersive, and alternative reality experiences for consumers needs to be supported but underpinned by ethical and moral principles.
- **Outdoors** – the cost and health benefits are considerable, so these ephemeral or temporal events should be encouraged and nurtured, including the ways that further attention can be drawn to the imperatives associated with preserving natural environments and the destructive effects of climate change.
- **Hybrid** – experimentation should continue in terms of how organisations and creatives present their work in various combinations, such as a festival with in-person events, online experiences, and pre- or post-event activities.
- **Covert** – the use of colour, design, artwork, and sound in the workplace, public venues, homes, and other industries needs to be given sufficient attention to promote the positive impacts that creativity can have in subtle but significant ways.

Workforces

Creative industries rely on paid and unpaid workers, each with a critical role to play. Key groups as well as issues relevant to the workforce include:

- **Employees** – there is tremendous variety in terms of the types of paid employment, and the systems for supporting workers within and outside traditional full-time roles need to be continually examined for equity, appropriateness, and sustainability.
- **Volunteers** – the sector would not exist without the efforts of passionate and committed citizens, whose roles should be increasingly valued.
- **Freelancers** – aside from paid work, which is largely self-generated, the notion of the "artist at work" (be this paid or unpaid) should be given appropriate recognition and support.

- **Inclusion and diversity** – there is a clear and ongoing need to investigate workforce policy settings, post-pandemic trends, and the extent to which the creative industries workforce should become even more balanced, diverse, and equitable.
- **Future workers** – those with a responsibility for shaping the future workforce should be supported and appreciated given the responsibility and importance of their roles, be they parents, mentors, employers, art educators, or policymakers.

Place

The ever-expanding palette of places for creative industries needs to be seen as a major opportunity but also one that requires reflection, refreshing, or igniting:

- **Physical** – venues of various sizes and configurations are crucial, however careful planning and re-conceptualisation of the future use of these spaces and the design of new venues is critical.
- **Natural** – the opportunity for low-impact and immersive experiences in various natural environments is considerable, with careful and thoughtful planning and design.
- **Domestic** – the forced shift in 2020 to work-from-home practices remains a reality for many creative industries stakeholders, whether by choice or employer requirement; hence, the nature of this semi-formalised place of working needs to be carefully considered, researched, and investigated by practitioners, academics, and industry leaders.
- **Virtual** – whether at home or on the move, the potential to engage consumers in both passive and interactive ways is a major opportunity moving forward, but one which has many unanswered questions and unresolved policy settings.
- **Personal** – people need to feel comfortable in the ways in which they identify and find their place in the creative industries across venues, styles, and formats, as well as their sense of identity and personal connections to and with creativity.

Ecosystems

The creative industries sector has its own unique ecosystem, one influenced by several intersecting structures and drivers, and the agency of its key creators, facilitators, audiences, and users. It is time to move on from the neoliberal and tired rhetoric of it being framed and lauded primarily as an "economy", given it is far more than simply a commercial and for-profit part of global societies. Its value lies in its

contribution to the health and wellbeing of peoples of any gender, race, age, and identity – from everyday creativity through to the highest levels of performance, creation, and practice. The main structures and frameworks underpinning and influencing the current and future creative industries ecosystem are:

- **Funding models** – the sector is underpinned by government investment, philanthropy, sponsorship, grants systems, private investment (e.g., crowdfunding), commercial markets, and consumer spending patterns. It is a relatively fragile sector in terms of its structures, and is subject to government ideologies and policies, neoliberal frameworks, copyright and royalty systems, shifting audience and user consumption patterns, and perceptions of value.
- **Policy** – policy settings, be they at national, state, or local levels, have a crucial role in creative industries ecosystems. They can be supportive and enabling, moderated and partially influential, or weak and ineffective. Cultural leaders and government stakeholders at various levels have considerable work to do in terms of how policy is revised in the light of recent disruption, innovation, and patterns of creative activity.
- **Business models** – there are a range of ways in which commerce operates in creative industries, from individual (freelance) artist models through to major corporate structures. The relationship between art and commerce is often contentious and potentially fracturing, however it is a necessary one in order that creatives can survive and prosper.
- **Innovations** – creative industries are driven by innovations within the sector, in terms of the creation of artefacts, product developments, the imagination of creatives, and audience demand models. The pandemic has and will continue to accelerate innovation within the sector; hence it is imperative that cultural leaders, government actors, and other key stakeholders facilitate and add value to these innovations going forward.

The World, Creative Industries and the Future

The pandemic has contributed significantly to the rising awareness of the perilous state in which the world exists at present. Artists and creatives will continue to be a critical group in relation to the ongoing climate change crisis, in response to geopolitical tensions and brutal conflicts happening in many countries such as Ukraine and Somalia, for social actions such as the Black Lives Matter movement, and in relation to growing global injustices, inequalities, poverty, and racism. Those in creative industries will therefore be crucial for reminding global citizens that amidst great turmoil and trauma, there is hope, hopefulness, a future, and the chance for a better world. The critical stakeholders in creative industries all need to continue to champion the value of the arts

and the ways in which it can bring love, healing, and solace during tumultuous times in history.

The importance of culture for the future is increasingly being recognised, with the UNESCO World Conference on Cultural Policies and Sustainable Development concluding that the preservation of culture needs to be recognised as its own sustainable development goal, based on the following reasons (Buse, 2023):

• culture can fight climate change;
• digital innovation must be ethical;
• cultural diversity matters;
• cultural objects must be returned; and
• culture is a global public good.

There was also recognition of culture in terms of its importance in supporting or complementing sustainable development goals in health, education, and the environment (Buse, 2023). It is with great hope that world leaders pay even more attention to the importance of culture and creative industries moving forward. The world needs this in order to heal and create a better future.

Closing Remarks

In closing, I leave for the reader – be they an artist, arts worker, consumer, audience member, parent, child, citizen, cultural leader, politician, policymaker, or educator – three important questions to contemplate:

• In what ways can I be a *hero* in and for creativity as the world continues to emerge from the devastation left by its current crises?
• In what ways can I assist with *celebrating* and *nurturing* creativity and creative people in my circle and beyond?
• How might I *apply* my creativity, regardless of its form and perceived impact, to leave this world a better place?

Finally, to borrow from Bono and U2, the creatively brilliant music supergroup from Ireland, whose concern and work for humanity will be remembered in history, I urge readers to find a moment amidst the ongoing chaos to pause, to breathe, to reflect, and then to *walk on*.

Reference

Buse, R. (2023, February 17). 6 takeaways from the world's biggest cultural policy gathering. *World Economic Forum*. https://www.weforum.org/agenda/2023/02/cultural-policy-sustainable-development

Index

For Product Safety Concerns and Information please contact our EU
representative GPSR@taylorandfrancis.com
Taylor & Francis Verlag GmbH, Kaufingerstraße 24, 80331 München, Germany

www.ingramcontent.com/pod-product-compliance
Lightning Source LLC
Chambersburg PA
CBHW061835220326
41599CB00027B/5291